The Artist's Painting Library

LANDSCAPES IN ACRYLIC

BY WENDON BLAKE / PAINTINGS BY RUDY DE REYNA

WATSON-GUPTILL PUBLICATIONS/NEW YORK

Copyright © 1980 by Billboard Ltd.

First published 1980 in the United States and Canada by Watson-Guptill Publications,
a division of Billboard Publications, Inc.,
1515 Broadway, New York, N.Y. 10036

Published in Great Britain by Pitman House, Ltd.,
39 Parker Street, London WC2B 5PB
ISBN 0-273-01359-9

Library of Congress Cataloging in Publication Data
Blake, Wendon.
 Landscapes in acrylic.
 (*His* The artist's painting library)
 Originally published as pt. 2 of the author's The
acrylic painting book.
 1. Landscape painting—Technique. 2. Polymer
painting—Technique. I. De Reyna, Rudy, 1914-
II. Title. III. Series: Blake, Wendon. Artist's
painting library.
ND1342.B54 1980 751.42'6 80-18902
ISBN 0-8230-2599-3 (pbk.)

All rights reserved. No part of this publication may be
reproduced or used in any form or by any means—graphic,
electronic, or mechanical, including photocopying, recording,
taping, or information storage and retrieval systems—
without written permission of the publishers.

Manufactured in U.S.A.

First Printing, 1980

CONTENTS

Landscapes in Acrylic. Painting landscapes in acrylic is a pleasure. If you work on the spot, you can work just as rapidly as you would in watercolor. If you work with broad areas of color and decisive strokes, you can finish a painting on location in a few hours. When you're ready to pack up and head for home, the painting is bone dry. If you prefer, you can make quick color studies on the spot and take them home for development into larger paintings. Or you can simply begin a painting outdoors and finish it in the studio. Back home, you can work at your leisure, overpainting areas that need adjustment, building up texture, and adding detail. Unlike oil paint, which takes days to dry, a coat of acrylic dries in minutes. And unlike watercolor, which can dissolve if you overpaint it too vigorously, a layer of dried acrylic is immovable. So you can overpaint a dozen times a day until you're satisfied.

Basic Techniques. *Landscapes in Acrylic* begins with a condensed review of our fundamental ways to handle acrylic paint—showing how these techniques might be used for typical landscape subjects. First you'll see how to paint mountains in the opaque technique. Then you'll see how another mountain landscape is painted in the transparent technique. The opaque picture will look somewhat like an oil painting, while the transparent technique will look somewhat more like a watercolor. You'll study a similar comparison in two sky paintings. First, a sky is painted in the opaque technique and then another sky is painted in the transparent technique. To show the drybrush technique, you'll see how the brush moves across the ridges of a rough painting surface to suggest the irregular texture and detail of trees. Then, a wintry landscape shows the scumbling technique in which the brush is scrubbed over the paper to deposit a semiopaque veil of color that suggests snow.

Color Sketches. A series of small color sketches will give you some guidelines for painting the colors of land, trees, and water. You'll compare the gray stony tones of distant mountains with the lush greens of tree-covered hills. You'll also compare the colors of deciduous trees, evergreens, and autumn trees. And you'll see how the colors of water change as they're influenced by the sky and the surrounding landscape.

Painting Demonstrations. Following the review of basic techniques and the color notes, you'll watch the noted painter Rudy de Reyna paint eleven complete landscapes, step-by-step. Each landscape will in-

corporate one or more of the basic techniques, and you'll learn a lot more about color mixing. The first demonstrations will show you how to paint various trees and growing things: deciduous trees, evergreens, an autumn forest, and a meadow filled with grasses and wildflowers. Then de Reyna moves on to the big, solid shapes of the landscape, demonstrating how to paint mountains, hills covered by vegetation, and a desert with its dramatic rock formations. A stream is painted to show you how to render moving water. Then you'll see how to paint two other forms of water—ice and snow. The painting demonstrations conclude with two sky pictures: a blue sky with massive white clouds and finally a sunset. Of course, these demonstrations are filled with many other details that you'll learn how to paint: rocks, pebbles, weeds, fallen leaves.

Special Problems. You'll also find guidance on selecting landscape subjects and some "rules of thumb" for composing effective landscapes. You'll see how the direction of the light can change the entire character of a tree or a rock. You'll see the difference between high key and low key—how to recognize these phenomena and how to paint them. You'll learn a very simple method of planning a landscape according to the "three value system." To train your powers of observation, there are demonstrations that show you how to draw rocks, clouds, and trees. These demonstrations will also teach you how to make on-the-spot drawings that you can assemble into paintings when you get back to the studio. Last of all, you'll see how an understanding of aerial perspective can enhance the feeling of space and atmosphere in your acrylic landscapes.

Outdoors or Indoors? Some people are outdoor painters who love to brave the elements (and the insects) to record what they see on location. Others are indoor painters, who like the leisure and comfort of home. Landscapes painted indoors can be just as exciting and just as authentic as those painted on the spot. But remember that the best landscape paintings always *start* outdoors, even if they're finished at home. Spend as much time as you can painting on location, even if those paintings are small, quick studies for larger paintings which you hope to develop in the studio. Working on location will strengthen your powers of observation and train your visual memory. The only way to learn about landscape is firsthand.

Color Selection. The paintings in this book were all done with a dozen basic colors—colors you'd normally keep on the palette—plus a couple of others kept on hand for special purposes. Although the leading manufacturers of acrylic colors will offer you as many as thirty inviting hues, few professionals use more than a dozen, and many artists get by with fewer. The colors listed below are really enough for a lifetime of painting. You'll notice that most colors are in pairs: two blues, two reds, two yellows, two browns, two greens. One member of each pair is bright, the other subdued, giving you the greatest possible range of color mixtures.

Blues. Ultramarine blue is a dark, subdued hue with a hint of violet. Phthalocyanine blue is far more brilliant and has tremendous tinting strength—which means that a little goes a long way when you mix it with another color. So add it very gradually.

Reds. Cadmium red light is a fiery red with a hint of orange. All cadmium colors have tremendous tinting strength; add them to mixtures just a bit at a time. Naphthol crimson is a darker red and has a slightly violet cast.

Yellows. Cadmium yellow light is a dazzling, sunny yellow with tremendous tinting strength, like all the cadmiums. Yellow ochre (or yellow oxide) is a soft, tannish tone.

Greens. Phthalocyanine green is a brilliant hue with great tinting strength, like the blue in the same family. Chromium oxide green is more muted.

Browns. Burnt umber is a dark, somber brown. Burnt sienna is a coppery brown with a suggestion of orange.

Black and White. Some manufacturers offer ivory black and others make mars black. The paintings in this book are done with mars black, which has slightly more tinting strength. But that's the only significant difference between the two blacks. Buy whichever one is available in your local art supply store. Titanium white is the standard that every manufacturer makes.

Optional Colors. One other brown, popular among portrait painters, is the soft, yellowish raw umber, which you can add to your palette when you need it. Hooker's green—brighter than chromium oxide green, but not as brilliant as phthalocyanine—may be a useful addition to your palette for painting landscapes full of trees and growing things. If you feel the need for a bright orange on your palette, make it cadmium orange—although you can just as easily create this hue by mixing cadmium red and cadmium yellow.

Gloss and Matte Mediums. Although you can simply thin acrylic tube color with water, most manufacturers produce liquid painting mediums for this purpose. Gloss medium will thin your paint to a delightful creamy consistency; if you add enough medium, the paint turns transparent and allows the underlying colors to shine through. As its name suggests, gloss medium dries to a shiny finish like an oil painting. Matte medium has exactly the same consistency, will also turn your color transparent if you add enough medium, but dries to a satin finish with no shine. It's a matter of taste. Try both and see which finish you prefer.

Gel Medium. Still another medium comes in a tube and is called gel because it has a consistency like very thick, homemade manyonnaise. The gel looks cloudy as it comes from the tube, but dries clear. Blended with tube color, gel produces a thick, juicy consistency that's lovely for heavily textured brush and knife painting.

Modeling Paste. Even thicker than gel is modeling paste, which comes in a can or jar and has a consistency more like clay because it contains marble dust. You can literally build a painting 1/4″ to 1/2″ (6 mm to 13 mm) thick if you blend your tube colors with modeling paste. But build gradually in several thin layers, allowing each one to dry before you apply the next, or the paste will crack.

Retarder. One of the advantages of acrylic is its rapid drying time, since it dries to the touch as soon as the water evaporates. If you find that it dries *too* fast, you can extend the drying time by blending retarder with your tube color.

Combining Mediums. You can also mix your tube colors with various combinations of these mediums to arrive at precisely the consistency you prefer. For example, a 50-50 blend of gloss and matte mediums will give you a semi-gloss surface. A combination of gel with one of the liquid mediums will give you a juicy, semi-liquid consistency. A simple mixture of tube color and modeling paste can sometimes be a bit gritty; this very thick paint will flow more smoothly if you add some liquid medium or gel.

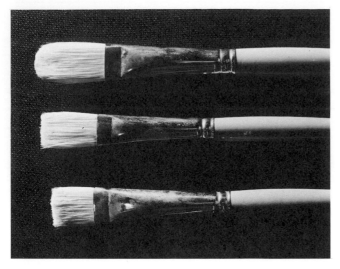

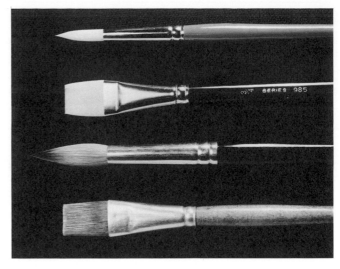

Bristle Brushes. For acrylic painting, you can use the same bristle brushes normally used in oil painting. The top brush is called a *filbert*; its long body of bristles, coming to a rounded tip, will make a soft, fluid stroke. The center brush is called a *flat*; its square body of bristles will make a squarish stroke. The bottom brush is called a *bright*; its short, stiff bristles can carry lots of thick paint and will make a stroke with a distinct texture. Bristle brushes are particularly good for applying thick color.

Nylon and Softhair Brushes. For applying more fluid color, many painters prefer softhair brushes. The top two are soft, white nylon; the round pointed brush is good for lines and details, while the flat one will cover broad areas. The third brush from the top is a sable watercolor brush, useful for applying very fluid color. (You can also buy a big, round brush like this one in white nylon, which will take more punishment than the delicate sable.) The bottom brush is a stiffer, golden brown nylon, equally useful for applying thick or thin color.

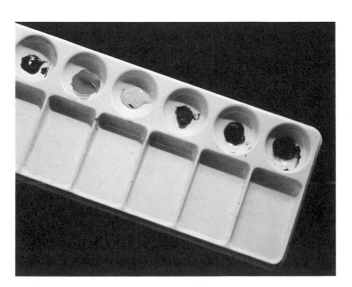

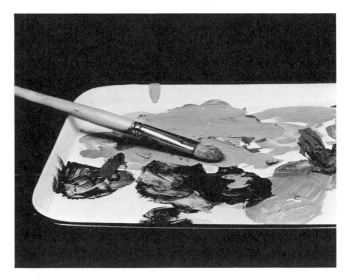

Watercolor Palette. This white plastic palette was originally designed for watercolor painting, but it works just as well for acrylic painting. You squeeze your tube color into the circular wells and then do your mixing in the rectangular compartments. These compartments slant down at one end; thus the color will run down and form pools if you add enough water.

Enamel Tray. For mixing large quantities of color, the most convenient palette is a white enamel tray—which you can buy wherever kitchen supplies are sold. You can use this tray by itself or in combination with one or two smaller plastic palettes like those used for watercolor.

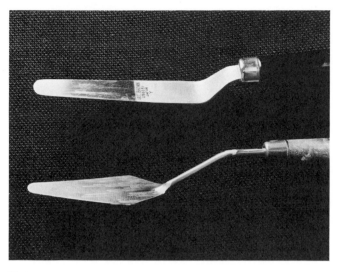

Knives. A palette knife (top) is useful for mixing thick color on your palette—before you add a lot of water—and for scraping wet color off the painting surface if you're dissatisfied with some part of the painting. A painting knife (bottom) has a thin, flexible blade which is designed to pick up thick color from the mixing surface and spread it on the painting surface. The side of the blade will make broad strokes, while the tip can add small touches of color.

Easel. For painting on canvas boards, canvas, or panels made of hardboard, most artists like to work on a vertical surface. A traditional wooden easel will hold the painting upright. An easel is essentially a wooden framework with two grippers that hold the painting firmly at top and bottom. Be sure to buy an easel which is solid and stable; don't get a flimsy easel that will tip over when you get carried away with vigorous brushwork.

Wooden Drawing Board. When you paint on watercolor paper—or any sturdy paper—it's best to tape the paper to a sheet of plywood or a sheet of hardboard cut slightly bigger than the painting. If you can, buy plywood or hardboard that's made for outdoor construction work; it's more resistant to moisture. Hold down the edges of the painting with masking tape that is at least 1″ (25 mm) wide or even wider.

Fiberboard. Illustration board is too thick to tape down, so use thumbtacks (drawing pins) or pushpins to secure the painting to a thick sheet of fiberboard. This board is 3/4″ (about 19 mm) thick and soft enough for the pins to penetrate. Note that the pins don't go *through* the painting, but simply overlap the edges.

Step 1. Used straight from the tube or diluted to a creamy consistency—with a little water or medium—acrylic paint is fairly opaque. That is, the color will conceal whatever is underneath. And since practically every mixture includes some white—the most opaque color on your palette—a mixture will be even more opaque than the pure tube color. The simplest way to apply acrylic paint is the opaque technique, which exploits the fact that one stroke will cover another. You'll see how this works in a demonstration painting of mountains. Here, the painting begins with a very simple line drawing in pencil on illustration board. There's not much point in a highly detailed drawing, since the paint will quickly cover the pencil lines.

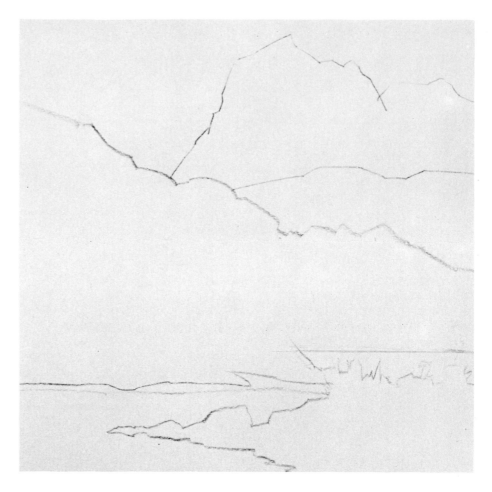

Step 2. The main shapes in the picture are covered with flat tones, working from light to dark. The sky and water are painted first in a mixture that contains plenty of white. Then comes the tall, distant mountain, containing a bit less white, followed by the darker, lower mountain to the right, which contains even less white. The dark shapes on either side of the water are painted last, and these contain practically no white. The color is diluted with just enough water to produce a smooth, flowing, creamy liquid—but not enough water to make this liquid transparent.

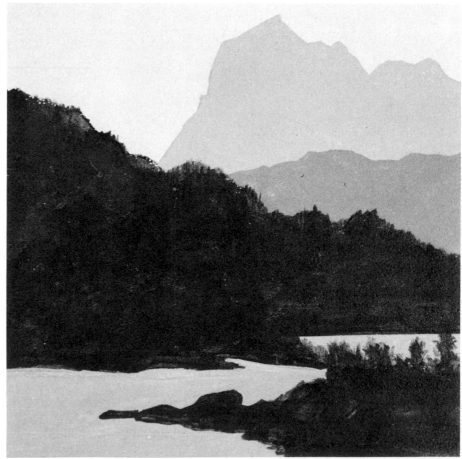

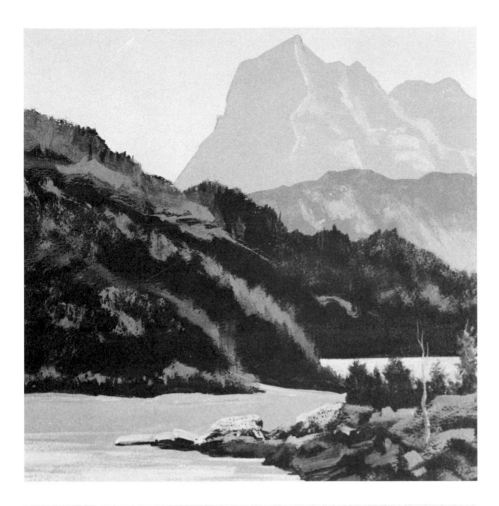

Step 3. Over these flat masses of tone, strokes of lighter color are applied to suggest detail. Containing plenty of opaque white, these strokes are dense enough to cover the darker tones underneath. The tip of a round brush picks out the lighted sides of the distant mountains. The sunlit foliage on the dark shore at the far edge of the stream, the sunlit tops of the rocks on the near shore, and some streaks of light on the water at the lower left. Acrylic dries quickly, so the flat tones of Step 2 are dry as a bone before they're covered with the lighter strokes of Step 3.

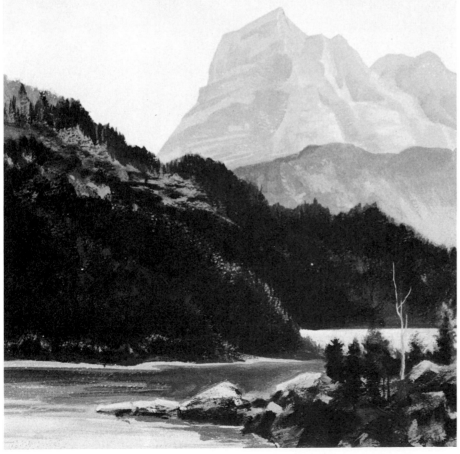

Step 4. When the light tones of Step 3 are dry, the picture is completed with small, dark and light strokes that suggest details. More light strokes are added over the darker tones of the distant peak. Dark strokes strengthen the shadows of the distant shore, partially concealing some of the lighter strokes that were added in Step 3. On the near shore, some darker shadows are added to the rocks; the sunlit tops of the rocks are brightened with lighter strokes; shadows and trunks are added to the trees. Dark reflections appear in the water. Throughout the picture, one opaque stroke covers another.

Step 1. Another way to apply acrylic paint is to thin your tube color with lots of water and steer clear of white paint altogether. Water, not white paint, makes your color paler. And the consistency of the paint is so fluid that you're really working with tinted water—very much like watercolor. Now you're working with transparent color— you can see right through it, as you'd see through a sheet of colored glass. Each successive layer of color *reveals* what's underneath. Here's another demonstration painting of a mountain, this time in the transparent technique, so you can see the difference between this and the opaque technique shown in the previous demonstration. The preliminary pencil lines are drawn on a sheet of watercolor paper.

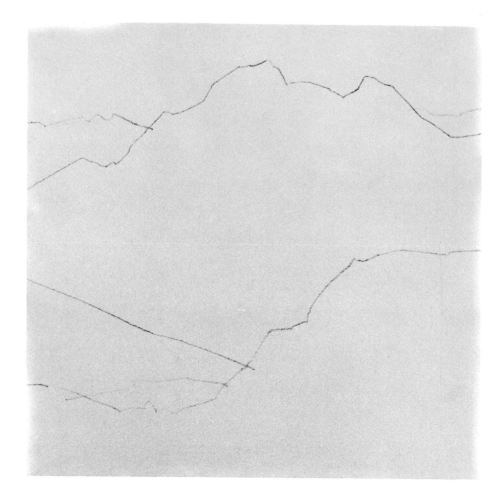

Step 2. Just a bit of tube color is mixed on the palette with lots of water, and a pale, even tone is brushed across the sky. When this tone dries, a slightly darker tone— still containing lots of water, but not quite as much—is brushed over the distant mountains to the right and left of the big peak. When these shapes are dry, a slightly darker tone is mixed for the big peak and carried down to the bottom of the picture in a series of overlapping, horizontal strokes which blur into one another to produce a smooth tone. Where the color grows paler beneath the midpoint of the picture, the strokes contain more water. Where the tone darkens at the very bottom the last few strokes contain more color. Notice the patch of bare paper in the lower left section, this will become a lake.

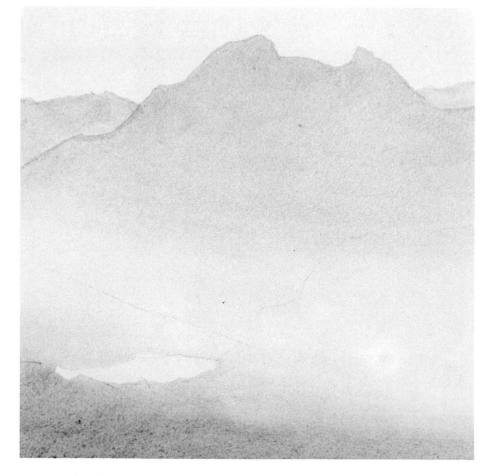

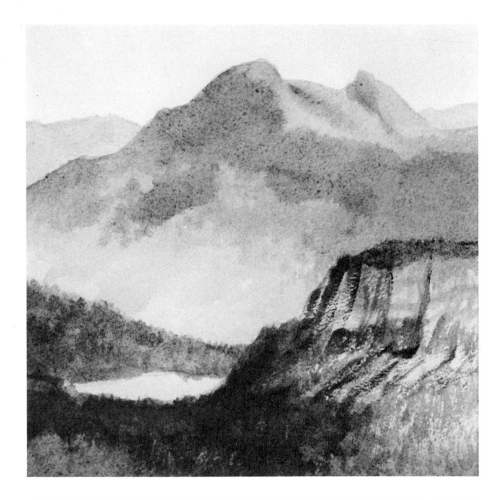

Step 3. In the *opaque* technique, you can paint dark over light or light over dark, whichever you choose. But in the *transparent* technique, you *must* paint dark over light. Over the flat tones painted in Step 2, darker tones are added for the shadows on the distant mountains. Shadows and dark details now begin to appear in the foreground and on the shoreline beyond the lake. These strokes contain a little less water and a little more tube color, but they're still transparent and almost as fluid as pure water. Notice how the rough texture of the watercolor paper breaks up the strokes in the foreground to suggest the textures of rocks and foliage.

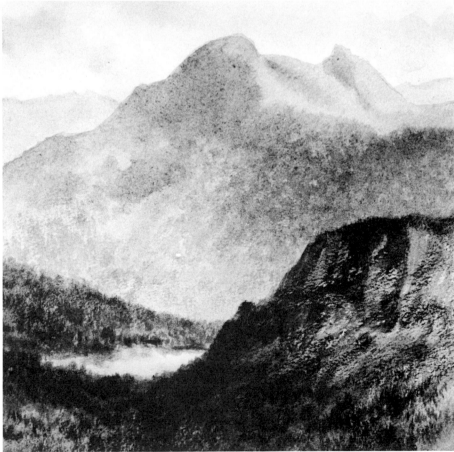

Step 4. When the tones of Step 3 are dry, more details are added with slightly darker strokes of fluid color. These strokes are carried right over the dry undertone, which shines through. You can see how many small touches of the brush tip suggest trees on the slopes of the distant mountain and more foliage on the rocky foreground. All the original tones are still there—enriched, but not concealed, by the final touches of the brush.

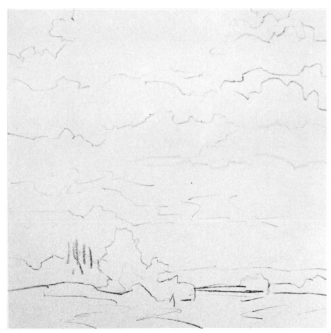

Step 1. Now see how a cloudy sky is painted in the opaque technique. The shapes of the clouds and the landscape beneath are drawn in pencil on a sheet of roughly textured illustration board. These pencil lines can be rough and casual, since the opaque color will quickly conceal them. In the process of painting, some of these cloud shapes will be altered.

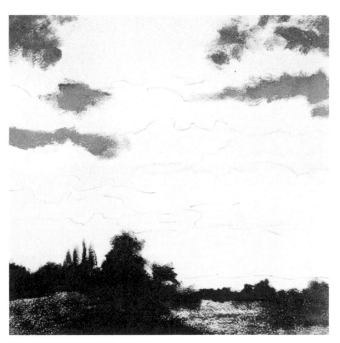

Step 2. The dark patches of sky between the clouds are painted with quick, rough strokes. So are the dark shapes on the horizon. These shapes will all be amended when lighter, opaque colors are painted around them and perhaps over them. So it's not necessary for these early strokes to be too precise.

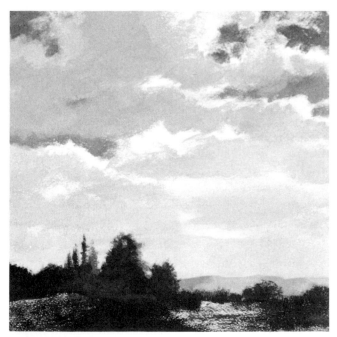

Step 3. The shadowy undersides of the clouds are painted next, leaving gaps of bare, white paper for the sunlit edges. Some of the dark sky shapes are beginning to change as the opaque shadow tones are carried over them. The distant hills are also painted in a pale, opaque tone. The clouds are painted in a technique called *scumbling*, which is a back-and-forth scrubbing motion that blurs the strokes.

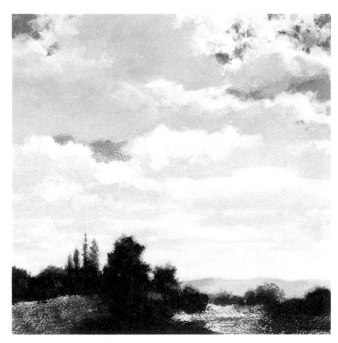

Step 4. Finally, the sunlit edges of the clouds are scumbled with thick, white, opaque color. Some of these strokes are carried over the patches of bare sky and over the shadows painted in Step 3, changing some of these darker shapes. Step 4 shows less bare sky than Step 2. Corrections are easy to make in opaque color.

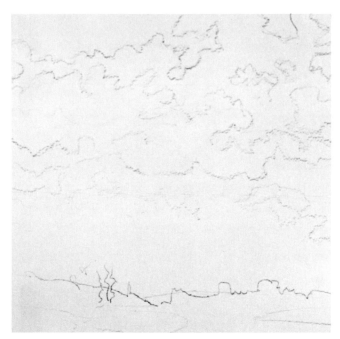

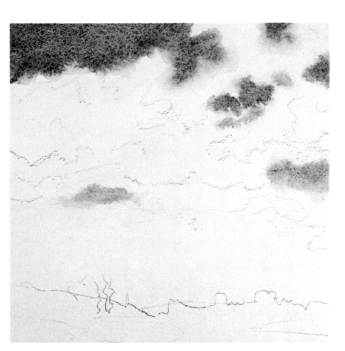

Step 1. The transparent technique is an excellent way to paint a sky, since the transparency of the color matches the luminosity of the subject. But the preliminary pencil drawing—on watercolor paper—must be more careful, since there's no way to change your mind and cover up a mistake. Transparent color won't hide what's underneath.

Step 2. Once again, the dark patches of bare sky are painted first. But they're painted exactly as they're going to appear in the finished painting, since their shapes can't be changed by later strokes of opaque color. To produce a soft, blurry effect, the sky is first brushed with clear water. The strokes blur when the brush touches the wet paper.

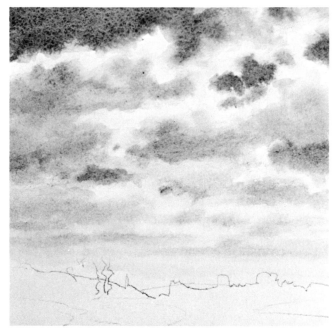

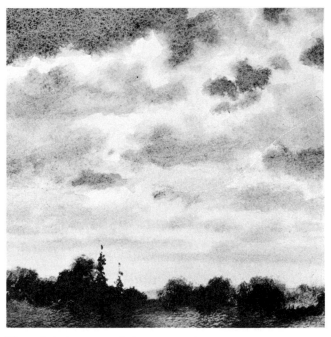

Step 3. The dark sky shapes of Step 2 are allowed to dry. Then more clear water is brushed over the paper. The shadowy undersides of the clouds are added, again blurring slightly on the wet surface. Because acrylic dries waterproof, the sky shapes that were painted in Step 2 won't be dissolved when the paper is rewetted. Painting on wet paper is called the wet-in-wet technique.

Step 4. When the sky is completely dry, the forms of the landscape are completed. The lighter tones are painted first and allowed to dry. Then the darker tones follow. The roughness of the paper tends to produce a ragged brushstroke that expresses the character of the trees.

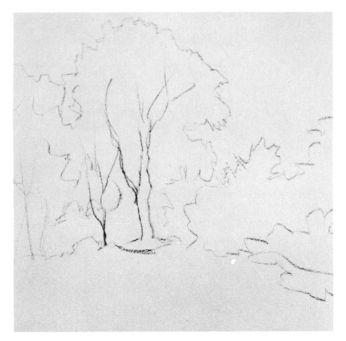

Step 1. To paint a landscape in the drybrush technique, it's best to pick a painting surface with a distinct texture—a surface with lots of peaks and valleys, such as a sheet of rough watercolor paper or roughly textured illustration board. In this preliminary pencil drawing, you can see how the *tooth* of the watercolor paper—the peaks and valleys of the painting surface—breaks up the pencil lines.

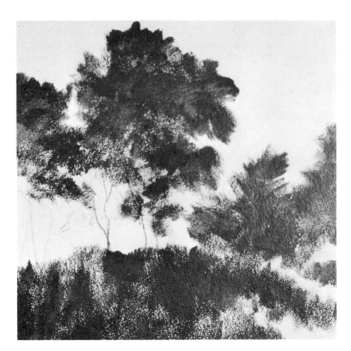

Step 2. The brush picks up a color mixture that doesn't contain too much water. The bristles are damp, not soaking wet. Moving across the textured painting surface, the brush deposits color on the peaks and skips over many of the valleys, which remain bare paper. The result is a speckled effect, perfect for suggesting foliage. The big masses of foliage are painted first.

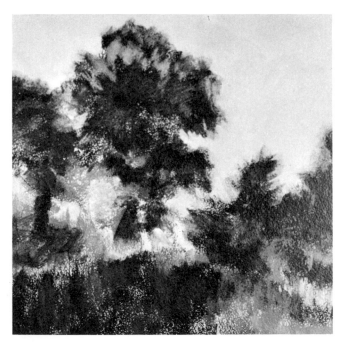

Step 3. The lighter areas—among the trees and on the meadow—are drybrushed next. If the brush seems to wet or the paint seems too fluid, you can wipe some off on a paper towel. The brush should carry *less* color than you'd need to paint a smooth, even tone. The lighter strokes easily cover the darks beneath, so it's obvious that the color is opaque.

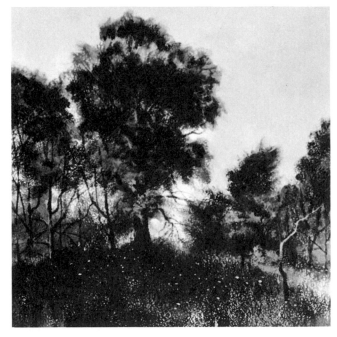

Step 4. Deep shadows are drybrushed under the leafy masses and on the patches of meadow directly beneath the trees. A path of sunlight is drybrushed beneath the trees at the lower right. Then the tip of a small round brush picks up more fluid color to add the precise details of treetrunks, branches, and a few pale spots that suggest wildflowers in the meadow.

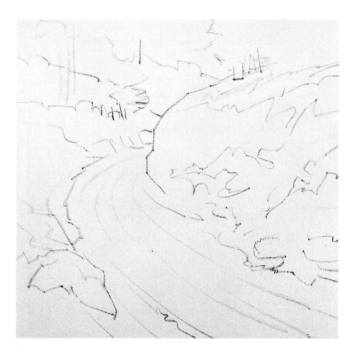

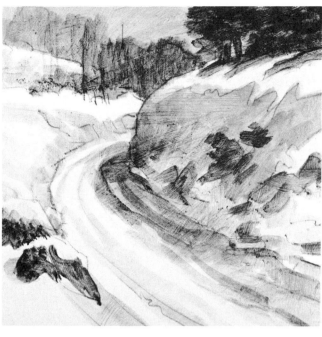

Step 1. You've seen how the back-and-forth scrubbing stroke called *scumbling* can paint the soft forms of clouds. Scumbling can also deposit semi-opaque veils of color that will produce luminous lights and shadows on a subject such as snow. This winter landscape begins with a pencil drawing on illustration board that's been thickly coated with acrylic gesso, retaining the marks of the brush.

Step 2. Transparent tones, containing lots of water, are freely brushed in to suggest the darks of the trees, the shadows on the sides of the snowbanks, and the shadowy ruts in the road. Within these transparent tones, you can see the irregular, streaky pattern of the brushstrokes in the gesso surface. The color is so transparent that you can still see the pencil lines.

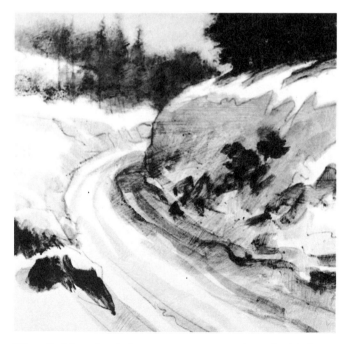

Step 3. Now the darkest areas are strengthened with heavier, more opaque color that's scrubbed over the trees on top of the snowbank, the more distant trees at the horizon, and the rocks in the foreground. Some of the ruts in the road are darkened too. The scrubby, back-and-forth brushwork tends to produce strokes with soft, slightly blurred edges—most apparent in the trees.

Step 4. Semi-opaque veils of pale color are scumbled over the sunlit tops of the snowbanks and blended softly into the shadows. A watery mixture of semi-opaque color is carried over the shadows of the big snowbank and the road—like a mist that still permits the underlying darkness to shine through. The picture is completed with a few brush lines to suggest trunks and branches.

Brushes. Because you can wash out a brush quickly when you switch from one color to another, you need very few brushes for acrylic painting. Two large flat brushes will do for covering big areas: a 1″ (25 mm) bristle brush, the kind you use for oil painting; and a softhair brush the same size, whether oxhair, squirrel hair, or soft white nylon. Then you'll need another bristle brush and another softhair brush, each half that size. For more detailed work, add a couple of round softhair brushes—let's say a number 10, which is about 1/4″ (6 mm) in diameter, and a number 6, which is about half as wide. If you find that you like working in the transparent technique, which means thinning acrylic paint to the consistency of watercolor, it might be helpful to add a big number 12 round softhair brush, either oxhair or soft white nylon. Since acrylic painting will subject brushes to a lot of wear and tear, few artists use their expensive sables.

Painting Surfaces. If you like to work on a smooth surface, use illustration board, which is white drawing paper with a stiff cardboard backing. For the transparent technique, the best surface is watercolor paper—and the most versatile watercolor paper is mouldmade 140 pound stock in the cold pressed surface (called a "not" surface in Britain). Acrylic handles beautifully on canvas, but make sure that the canvas is coated with white acrylic paint, not white oil paint. Your art supply store will also sell inexpensive canvas boards—thin canvas glued to cardboard—that are usually coated with white acrylic, which is excellent for acrylic painting. You can create your own painting surface by coating hardboard with acrylic gesso, a thick, white acrylic paint which comes in cans or jars. For a smooth surface, brush on several thin coats of acrylic gesso diluted with water to the consistency of milk. For a rougher surface, brush on the gesso straight from the can so that the white coating retains the marks of the brush. Use a big nylon housepainter's brush.

Drawing Board. To support your illustration board or watercolor paper while you work, the simplest solution is a piece of hardboard. Just tack or tape your painting surface to the hardboard and rest it on a tabletop, with a book under the back edge of your board so that it slants towards you. You can tack down a canvas board in the same way. If you like to work on a vertical surface—which many artists prefer when they're painting on canvas, canvas board, or hardboard coated with gesso—a wooden easel is the solution. If your budget permits, you may like a wooden drawing table that you can tilt to a horizontal, diagonal, or vertical position just by turning a knob.

Palette. One of the most popular palettes is the least expensive—just squeeze out and mix your colors on a white enamel tray, which you can probably find in a shop that sells kitchen supplies. Another good choice is a white metal or plastic palette (the kind used for watercolor) with compartments into which you squeeze your tube colors. Some acrylic painters like the paper palettes used by oil painters: a pad of waterproof pages that you tear off and discard after painting.

Odds and Ends. For working outdoors, it's helpful to have a wood or metal paintbox with compartments for tubes, brushes, bottles of medium, knives, and other accessories. You can buy a tear-off paper palette and canvas boards that fit neatly into the box. Many acrylic painters carry their gear in a toolbox or a fishing tackle box, both of which also have lots of compartments. Two types of knives are helpful: a palette knife for mixing color; and a sharp one with a retractable blade (or some single-edge razor blades) to cut paper, illustration board, or tape. Paper towels and a sponge are useful for cleaning up—and they can also be used for painting, as you'll see later. You'll need an HB drawing pencil or just an ordinary office pencil for sketching in your composition before you start to paint. To erase pencil lines, get a kneaded rubber (or "putty rubber") eraser, which is so soft that you can shape it like clay and erase a pencil line without abrading the surface. To hold down that paper or board, get a roll of 1″ (25 mm) masking tape and a handful of thumbtacks (drawing pins) or pushpins. To carry water when you work outdoors, you can take a discarded plastic detergent bottle (if it's big enough to hold a couple of quarts or liters) or buy a water bottle or canteen in a store that sells camping supplies. For the studio, find three wide-mouthed glass jars, each big enough to hold a quart or a liter.

Work Layout. Before you start to paint, lay out your supplies and equipment in a consistent way so that everything is always in its place when you reach for it. Obviously, your drawing board or easel is directly in front of you. If you're right-handed, place your palette, those three jars, and a cup of medium to the right. In one jar, store your brushes, hair end up. Fill the other two jars with clear water: one is for washing your brushes; the other provides water for diluting your colors. Establish a fixed location for each color on your palette. One good way is to place your *cool* colors (black, blue, green) at one end and the *warm* colors (yellow, orange, red, brown) at the other. Put a big dab of white in a distant corner, where it won't be fouled by the other colors.

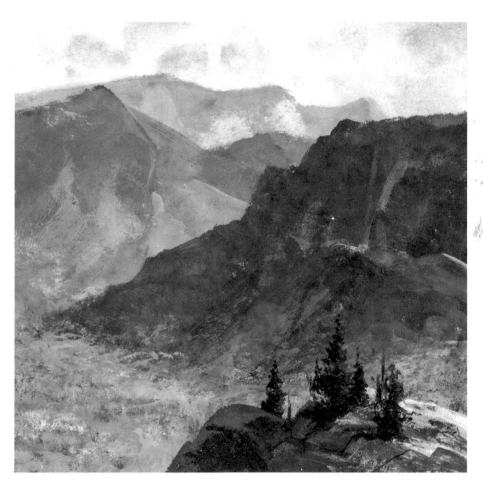

Mountains. The stony forms of mountains are far more colorful than you might think at first glance. The diverse browns, gray-browns, and blue-grays of this landscape are mainly mixtures of blues and browns. The darkest mountain is a blend of burnt umber, ultramarine blue, yellow ochre, and white—with more white and yellow ochre in the lighter areas, more blue and brown in the shadows. The more distant mountains are mixtures of burnt sienna, ultramarine blue, white, and yellow ochre—with lots of white in the lighted areas and lots of blue in the shadows. The rocks in the lower right are essentially the same mixtures as the darker mountain. Mountains are just big piles of rock, after all.

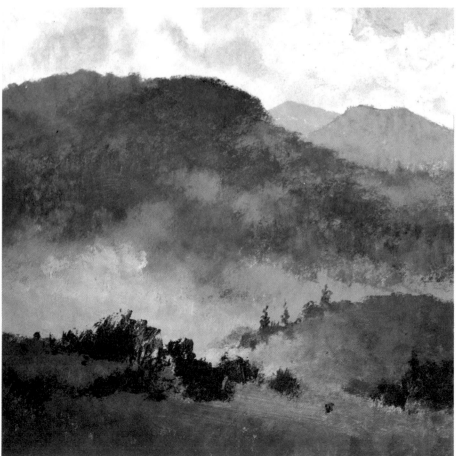

Hills. When you paint hills covered with trees and underbrush, try to emphasize the variety of color within the green. Don't try to paint each tree on the side of the hill; paint masses of trees that merge with one another but still have their own distinct colors. This green hill is a subtle patchwork of various green mixtures: ultramarine blue and cadmium yellow; ultramarine blue and yellow ochre; phthalocyanine blue and yellow ochre; phthalocyanine blue, cadmium yellow, and a touch of burnt umber to soften this brilliant mixture; phthalocyanine green and burnt sienna; mars black and yellow ochre for the most muted greens of all. The sunlit meadow at the foot of the hill consists of several of these mixtures, with more white.

Deciduous Tree. Don't try to paint every leaf with precise strokes, but paint the *masses* of leaves with broad strokes. Note that these masses have sunlit and shadow sides. Here, the sunlit sides are ultramarine blue and cadmium yellow, plus a little white, while the shadowy areas are ultramarine blue, yellow ochre, and burnt sienna. On the grass at the foot of the tree, the light and shadow areas are the same mixtures. And these mixtures reappear in the paler tones of the distant trees, which obviously contain much more white. The trunk of the big tree is ultramarine blue, burnt sienna, yellow ochre, and white—with more white on the sunlit side.

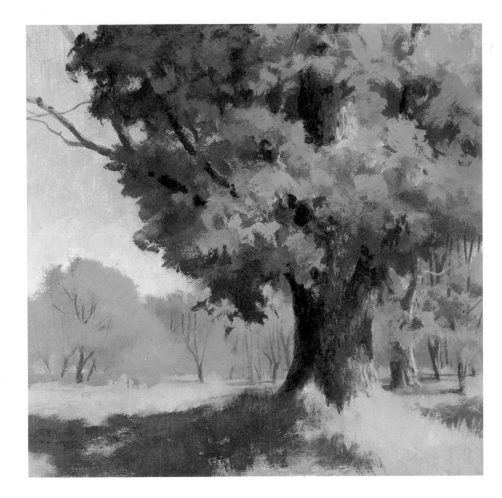

Evergreen. Pines, spruces, firs, and other evergreens tend to be a darker, less sunny green than deciduous trees. Once again, don't paint every needle, but try to paint the masses of foliage, paying attention to their sunlit and shaded sides. Some good mixtures for the sunlit sides are phthalocyanine blue, yellow ochre, and burnt umber, or ultramarine blue, cadmium yellow, and burnt sienna—with some white, of course. For the darks, you can use the same mixtures, but with less yellow and white. The distant trees contain more white in both the lights and the shadows. To create other muted greens, try modifying the brilliant phthalocyanine green or the more subdued chromium oxide green with a brown like burnt umber or burnt sienna, plus yellow ochre and white.

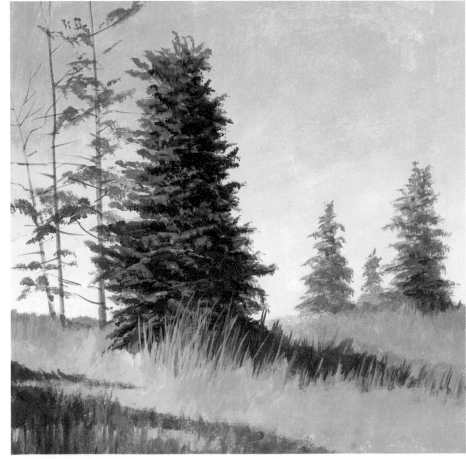

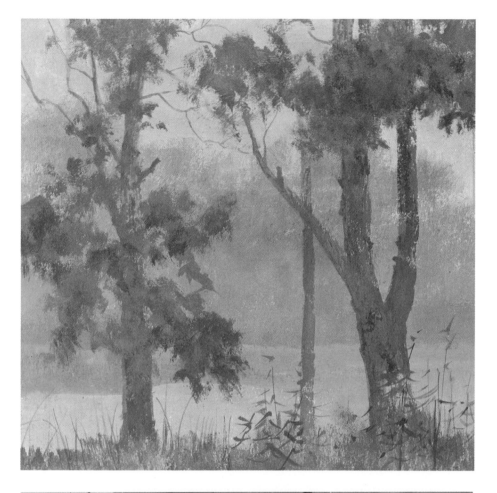

Trees in Mist. On a misty day, trees lose their brilliant colors, but new, equally interesting, colors emerge. You can mix lovely, muted greens, like the foliage in the foreground, with ultramarine blue, yellow ochre, white, and perhaps a touch of burnt umber or burnt sienna. You can also use just a little phthalocyanine blue or phthalocyanine green, burnt umber or burnt sienna, yellow ochre, and white, or mars black, cadmium yellow, and white. You can quickly transform any blue or green into a pale, atmospheric tone by adding brown and lots of white. That's how the ghostly forms of the distant trees are painted here.

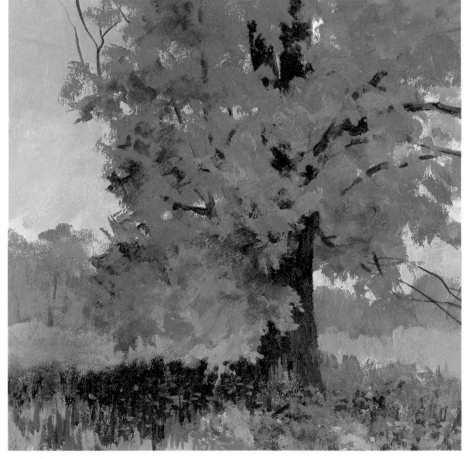

Autumn Tree. The brilliant colors of an autumn tree can be just as monotonous as the side of a green hill if you don't look for variations within those hot colors. It's also best to mingle the brilliant mixtures with more muted tones, as you see here. The brightest clusters of leaves are cadmium red and cadmium yellow. (You could also try cadmium orange, yellow ochre, and a touch of cadmium red.) The softer, golden tones are cadmium red, yellow ochre, white, and an occasional touch of burnt sienna. The darker, coppery tones in the shadows are cadmium red, burnt umber, yellow ochre, and a touch of white. Small strokes of these same mixtures suggest fallen leaves at the foot of the tree. For other autumn colors, try mixing burnt sienna and cadmium yellow, or naphthol crimson and cadmium yellow, or burnt umber and cadmium orange.

Pond in Sunlight. Water is essentially a reflecting surface, which means that it has no color of its own, but takes its color from its surroundings. Most often, a body of water reflects the color of the sky. So it's not surprising that this pond repeats the blues and whites of the sky and clouds above. Along the shoreline, of course, the pond reflects the tones of trees and grass—not only the sunny greens, but the shadow tones as well. Across these darker reflections move a few ripples that reflect the color of the sky. To produce delicate blues, add plenty of white to ultramarine or phthalocyanine blue, then modify the mixture with the slightest touch of burnt umber, burnt sienna, or yellow ochre.

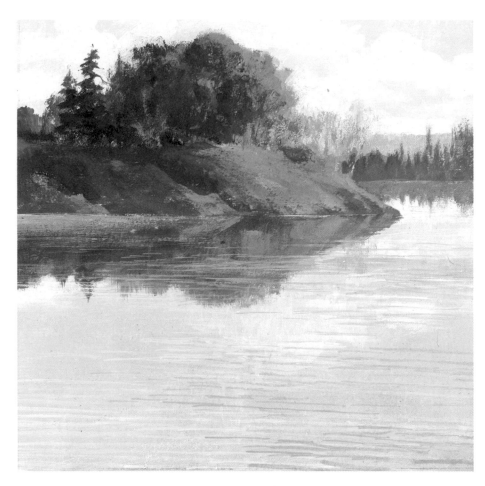

Pond in Deep Woods. Surrounded by the shadowy forms of trees and rocks that block out most of the sky, a body of water will turn a totally different color. This pond is dominated by the dark tones of the surrounding landscape, reflecting just a small patch of pale sky that breaks through the trees. These trees and rocks—and their reflections—are mixtures of burnt umber, ultramarine blue, yellow ochre, and white. You can also produce mysterious, shadowy mixtures with mars black, yellow ochre, and white; or phthalocyanine green, burnt umber, and white; or Hooker's green, burnt sienna, and white.

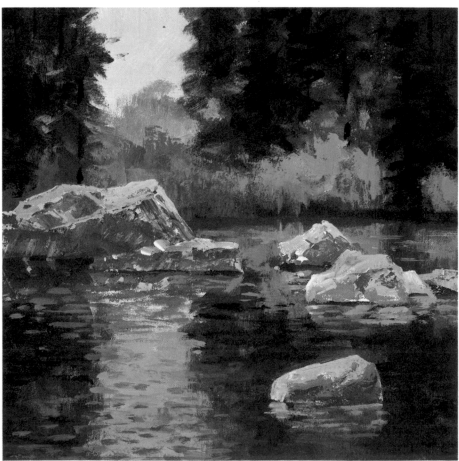

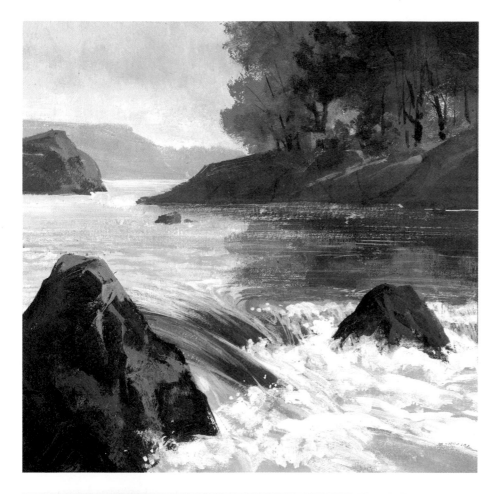

Stream. In moving water, the color effects are more complicated. Just above the rock in the lower left, the water reflects the colors of the sky. To the right of the sky tone, the water picks up the colors of the trees and rocks on the distant shore—with sky colors appearing among the pale ripples. But in the foreground, where the rapids burst into foam, several different things happen at once. Where the water rushes over the rocks, you can see the darkness of the concealed rocks shining through. As the rushing water bursts into foam, it turns white, but then the shadows beneath the foam pick up the sky color once again. Never paint foam ''dead white'': add a hint of sky color or a touch of sunlight.

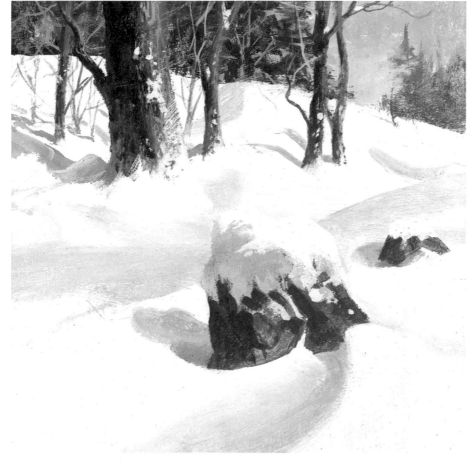

Snow. When you paint snow, the most important thing to remember is that snow is simply water in another form—and obeys the same ''laws'': like a pond or a stream, snow has no special color of its own, but reflects the colors of its surroundings. On a sunny day, the lighted tops of snowbanks seem to reflect the warm glow of the sunlight, while the shadows pick up the cooler tones of the sky. Within the shadows cast by these treetrunks—and particularly in the shadow cast by the big rock in the immediate foreground—you can also see a subtle reflection of the dark tone of bark or stone. Snow, like foam, should never be painted pure white: on a bright day, add a hint of sunlight; on an overcast day, add a hint of gray.

Step 1. This demonstration painting of a tree begins with a pencil drawing that defines the contours of the trunks and branches, the curves of the meadow, the shapes of the three rocks beneath the tree, and the clusters of leaves against the sky. The lines of the tree and rocks will be followed carefully in the final painting. But the shapes of the leafy clusters and the landscape will disappear under rough, impulsive brushwork, so a precise drawing isn't really essential. The main thing is to establish the locations and the general shapes of the leafy masses and the horizon.

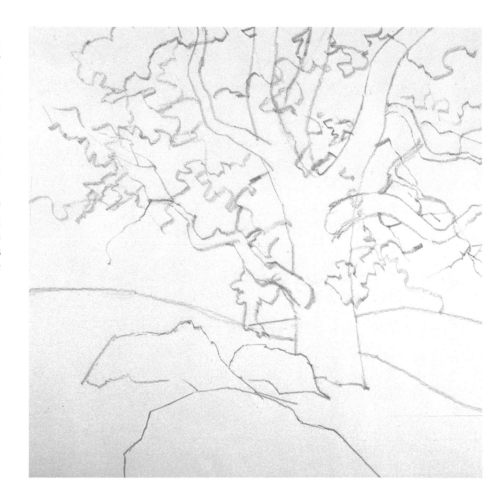

Step 2. A mixture of white, a touch of ultramarine blue, and lots of water is brushed over the entire surface of the illustration board, casting a semi-opaque veil over the pencil drawing, which is now almost invisible—just a faint "ghost" of the lines remains. A flat bristle brush covers the top half of the picture with a sky tone: ultramarine blue and white at the top, and ultramarine blue, phthalocyanine blue, yellow ochre, and white for the paler tone that approaches the horizon. When this sky tone is dry, the tree can be painted right over it without disturbing the underlying color.

Step 3. The foliage along the horizon and against the sky is painted with short, scrubby strokes of thick color—not too much water—containing ultramarine blue, yellow ochre, and white. Now it's getting too hard to see the faint lines of the treetrunk and branches, so they're redrawn in pencil over the dried color of the sky and the distant foliage. The grassy tones of the meadow are painted with the same short, scumbling strokes of a bristle brush, carrying dark and light mixtures of ultramarine blue, yellow ochre, cadmium yellow, and white. There's more yellow to the left and more blue in the shadowy tone at the lower right.

Step 4. A small bristle brush scrubs a thin mixture of burnt umber, chromium oxide green, and white over the trunk and branches. (The grayish tone of the bark would be a lot less interesting if it were merely a mixture of black and white!) Then a painting knife picks up a thick mixture of white, yellow ochre, and gel medium. This pasty color is roughly stroked over the shapes of the three rocks, leaving a ragged, irregular texture. It's important to let this *impasto* passage dry thoroughly before going back to work on the rocks.

Step 5. When the rocks are bone dry, they're glazed with a transparent mixture of cadmium red, yellow ochre, ultramarine blue, and gloss painting medium, applied with a softhair brush. This glaze settles into all the cracks and crevices left by the painting knife at the end of Step 4. Then the foliage on the tree is begun with quick taps of the tip of a bristle brush, carrying two different mixtures: ultramarine blue, cadmium yellow, and white for the sunlit leaves; phthalocyanine blue, yellow ochre, cadmium yellow, and white for the darker clusters of leaves.

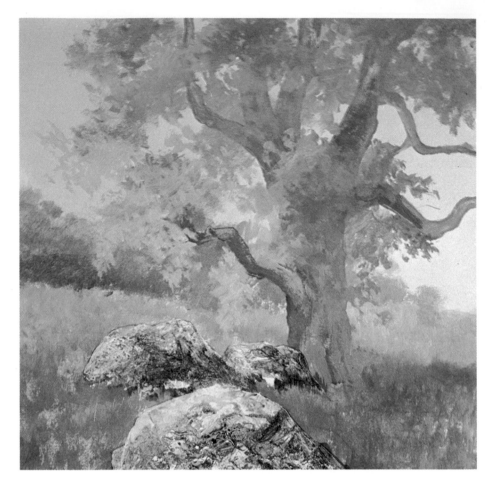

Step 6. The shadows on the trunk and the branches are begun with ultramarine blue and burnt sienna—the strokes follow the upward curves of the tree. The shadow to the right of the tree is painted with short, scrubby strokes of a bristle brush that suggest the texture of the grass with a mixture of Hooker's green and burnt sienna. Then, with the same tapping motion that first appeared in Step 5, the rich, dark greens of the lower leaves are added with Hooker's green, burnt sienna, cadmium yellow, and just a little white. The color used to paint the foliage is fairly thick—not diluted with too much water or painting medium—so it retains the marks of the bristles, suggesting leaves. Notice that a pale, greenish wash of this leaf mixture, containing lots of water, is carried over the rocks.

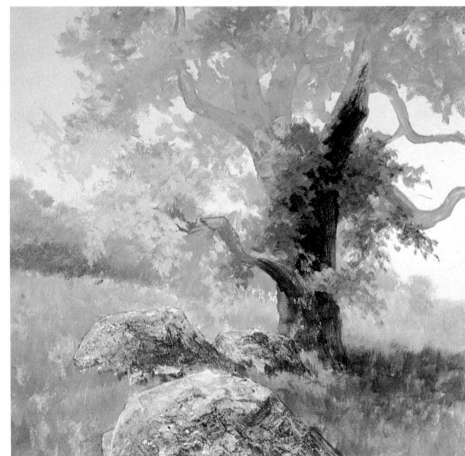

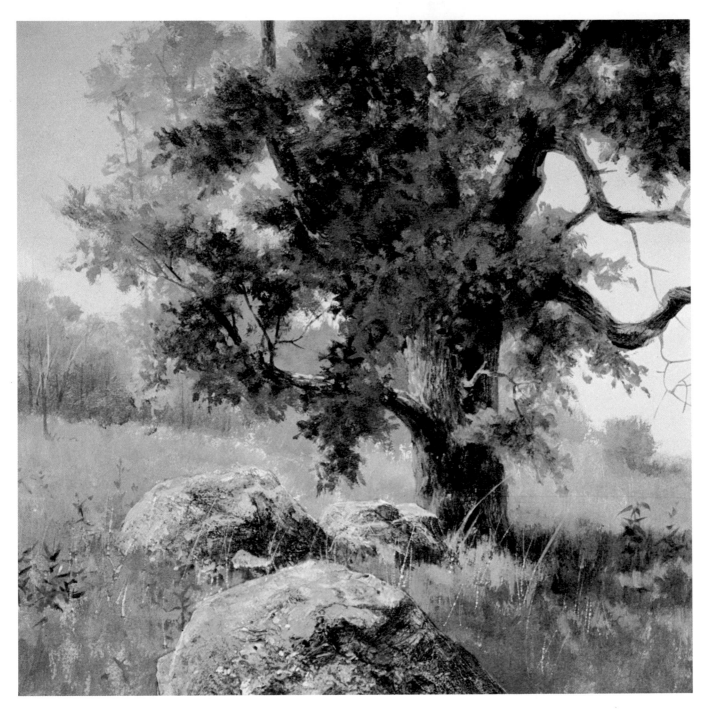

Step 7. Quick, tapping strokes of this mixture of Hooker's green, burnt sienna, cadmium yellow, and a touch of white are carried upward to cover all the deep green shadows of the foliage. Amid these shadowy clusters of leaves, you can see even deeper tones: mixtures of ultramarine blue, Hooker's green, and burnt sienna. More light and dark strokes of Hooker's green, burnt sienna, cadmium yellow, and white are scrubbed over the grass in the foreground. The shadows and dark lines on the trunk and branches are completed with slender strokes of ultramarine blue and burnt sienna, made with the tip of a round softhair brush. More twigs are added to the big tree, and trunks are added to the distant trees in the upper left with a pale mixture of ultramarine blue, burnt sienna, yellow ochre, and white.

Some pale strokes of this same mixture—containing lots of white—are dragged over the tops of the rocks to strengthen the contrast of light and shadow. Then the shadow sides of the rocks are deepened with the same mixture used on the trunk. Final details are added with the sharp corner of a razor blade and the pointed tip of a small, round softhair brush. The blade scratches weeds and blades of grass in the meadow. The round brush picks up some of the tree mixtures to add some leafy weeds. Look again at the foliage on the tree. The edges of the leafy masses, caught in sunlight, are a brilliant yellow-green. But most of the foliage is really in shadow. If you half-close your eyes, you'll see that the tree is essentially a shadowy silhouette.

Step 1. Like the deciduous tree in Demonstration 1, this painting of a group of evergreens begins with a precise pencil drawing of the trunks and branches, but a much more casual indication of the masses of foliage. It's important to visualize foliage as big, simple shapes. Just draw the general outlines of these shapes in pencil, but don't follow the drawing too closely when you start to paint. Foliage must be painted with free, ragged strokes, which will soon cover up these pencil lines.

Step 2. The pencil drawing is partly concealed by a "mist" of white, a little ultramarine blue, and a lot of water, so the lines are almost invisible. Then the sky is painted in two operations. First, the sky is brushed with clear water. While the surface of the illustration board is still wet and slightly shiny, a mixture of ultramarine blue and phthalocyanine blue is carried from the top of the picture down to the horizon, gradually adding more water as the brush approaches the horizon, so the sky is dark at the top and pale below. This *graded wash*, as it's called, is allowed to dry. Then the sky is again wetted with clear water and the same type of graded wash is carried upward from the horizon; this time, the mixture is simply naphthol crimson and water, with more color at the horizon and more water at the top.

Step 3. The grassy area is scribbled with up-and-down strokes of a flat bristle brush dampened with burnt sienna and water. Because the brush carries so little color, the marks of the bristles are clearly seen and give the distinct impression of blades of grass. When this scrubby passage dries, it's covered with a fluid, transparent glaze of yellow ochre and water, applied with a large softhair brush. When the yellow ochre dries, the strokes of burnt sienna shine through.

Step 4. The distant trees along the horizon are painted with short, scrubby strokes of ultramarine blue, cadmium red, yellow ochre, and white, applied with a bristle brush. This same tone, containing more water and more white, is carried over the upper half of the meadow, just beneath the trees—the color is a thin scumble, so the tones of Step 3 still shine through. The immediate foreground is glazed with a transparent wash of chromium oxide green and ultramarine blue, applied with a large softhair brush; again, the tones of Step 3 shine through the transparent glaze. It's getting hard to see the lines of the trees, so they're lightly redrawn in pencil.

Step 5. A bristle brush scrubs a mixture of Hooker's green and yellow ochre over the foliage areas of the pines in the foreground. The color on the brush is damp, not really wet, so the strokes have a ragged quality that suggests clusters of pine needles. The tip of a small, round softhair brush builds up the trunks and branches with many little lines of Hooker's green and burnt sienna. Look closely at the trunks and you can see that they're not one solid tone, but are composed of many parallel lines that suggest the texture of the bark.

Step 6. The shadow tones on the foreground pines are painted with the same brush and the same type of brushwork, but the colors are a bit more fluid and "juicy." These darks are a mixture of Hooker's green and burnt sienna thinned with water to the consistency of watercolor, containing no white. The bristles of the brush now leave a very distinct mark that suggests pine needles even more clearly. These dark strokes are allowed to dry, and then more scrubs of this dark mixture are added to certain areas where the shadows are particularly dense.

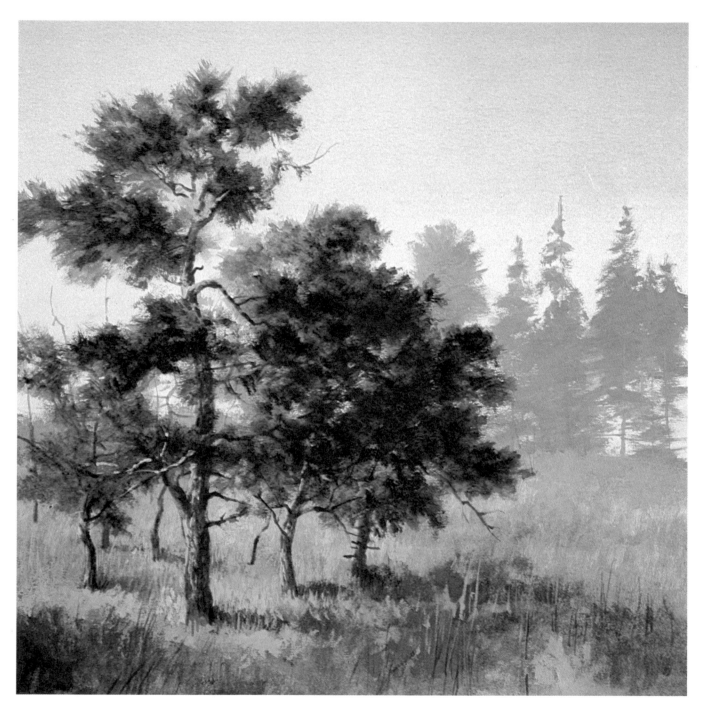

Step 7. The foreground of the meadow is enriched with scumbling strokes of thick color: burnt sienna, cadmium yellow, a touch of Hooker's green, and lots of white in the sunlit areas; ultramarine blue, burnt sienna, yellow ochre, and a touch of white in the shadows. The broad tones are painted with a flat bristle brush. Notice how the tip of a small, round softhair brush carries blades of sunlit grass up over the shadows. The same brush strikes in darker blades of grass with a mixture of ultramarine blue, Hooker's green, and burnt sienna. This small brush strengthens the shadow sides of the trunks and branches with the same mixture, then blends white into this mixture and adds a few strokes of sunlight to the left sides of the trunks and branches. This painting is an interesting combination of transparent and opaque color—a combination that's particularly effective for painting atmospheric landscapes. The sky is completely transparent. The meadow begins with transparent color and is completed with more opaque color. Conversely, the trees begin with opaque color and are finished with transparent color that gives you the sensation of luminous shadows.

Step 1. There's so much detail in a forest that it's important to be highly selective about just how much to include. All that foliage can become just one big blur, so it's critical to focus on just a few treetrunks of various sizes and make them the dominant shapes in the picture. In the pencil drawing, it's obvious that the picture will be dominated by one thick trunk to the left, played off against some smaller trunks to the right and some really slender trunks in the distance. Once again, the treetrunks and branches are drawn precisely, while the clusters of foliage are merely indicated with casual lines. The drawing also defines the shape of the shadow at the foot of the large tree.

Step 2. The final painting will have a patch of bright sunlight breaking through the dense foliage. So this sunlit break is indicated with a pale wash of cadmium yellow and yellow ochre, thinned with water to the consistency of watercolor. When this yellow shape dries, it's surrounded by a warmer, darker tone that suggests the overall color of the surrounding woods: a mixture of naphthol crimson, yellow ochre, ultramarine blue, and lots of water. You've probably noticed that the original pencil lines are almost invisible once again, having been covered with a "mist" of white, ultramarine blue, and water, which is allowed to dry before the painting operation begins.

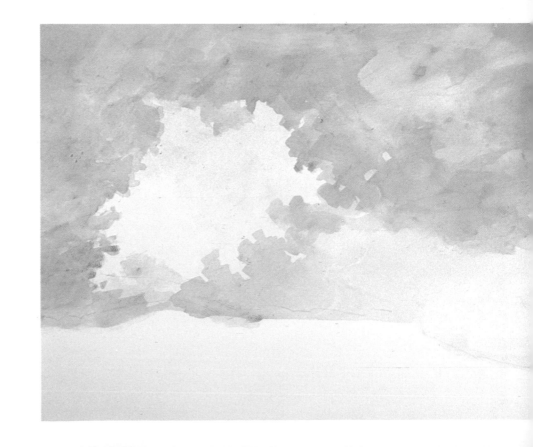

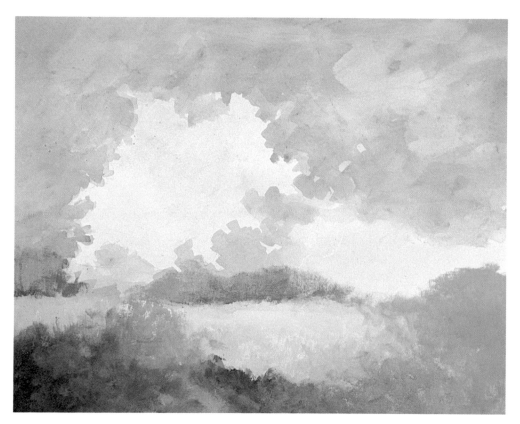

Step 3. The sunlit patch of ground is scumbled with a mixture of cadmium yellow, yellow ochre, and burnt sienna. The dark tones above this and to the right are mixtures of naphthol crimson, ultramarine blue, yellow ochre, and white. And the rich tone in the lower left is cadmium red, cadmium yellow, and burnt umber. All these tones are scumbled in with the short, stiff bristles of the brush known as a *bright*. The color is thick and opaque.

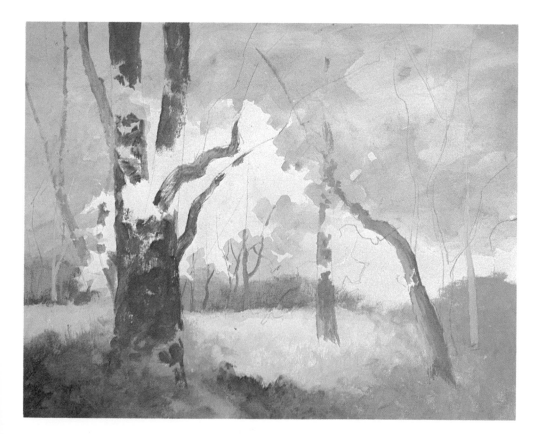

Step 4. The trunks and branches are redrawn with light pencil lines. The thick trunk is begun with a small, flat bristle brush carrying a much darker version of the mixture used in Step 3: ultramarine blue, naphthol crimson, yellow ochre, and white. This same mixture appears in the shadowy tone to the right of the tree. And the point of a round softhair brush begins to trace the slender shapes of the smaller trunks with the same mixture, which now contains more white.

Step 5. The glowing colors of the foliage are tapped in with the tip of a bristle bright carrying a mixture of cadmium red, cadmium yellow, yellow ochre, and white. The dark note on the side of the tree—naphthol crimson, yellow ochre, and ultramarine blue—is scrubbed in with the longer, more flexible bristles of a *flat*. At this point, all the color is thick and opaque, gradually covering most of the transparent sky tones.

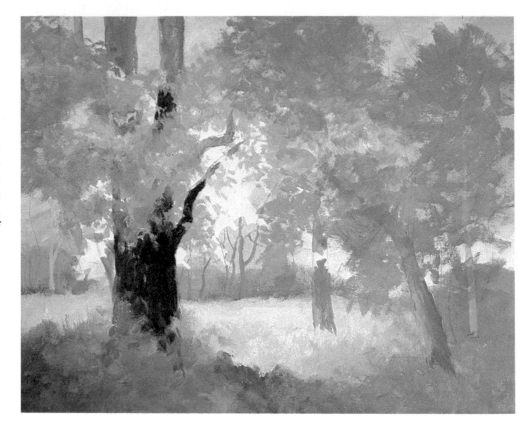

Step 6. The dark mixture of naphthol crimson, yellow ochre, and ultramarine blue is carried up over the main trunk and branches, leaving the paler undertone uncovered here and there to suggest lighter patches. Short strokes of the same dark mixture are scattered at the foot of the tree to suggest shadows in the underbrush. A large bristle brush adds darker tones to the foliage: various mixtures of naphthol crimson, cadmium red, cadmium yellow, yellow ochre, ultramarine blue, and white—never more than three colors to a mixture. The darks in the upper right corner are cadmium red, ultramarine blue, yellow ochre, and a little white.

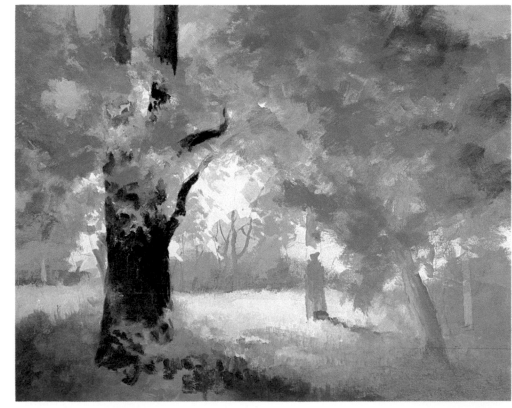

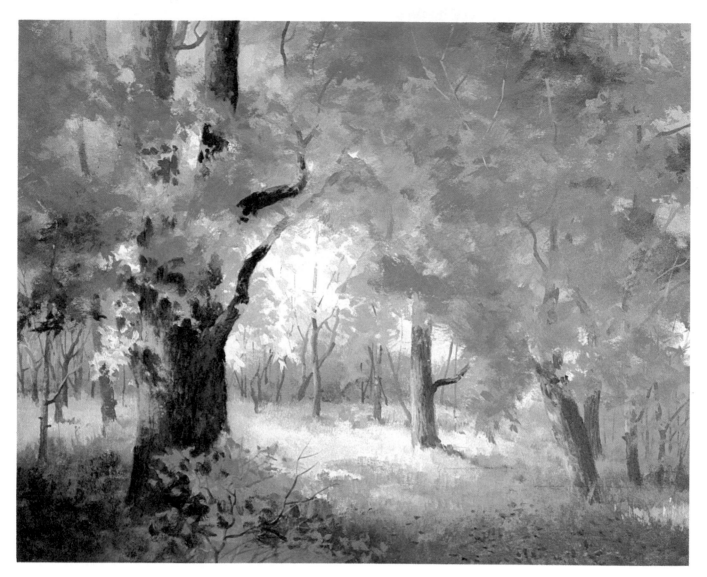

Step 7. The foliage is completed by alternating strokes of the gold and coppery mixtures introduced in Steps 5 and 6. Darks are added to the sides of the smaller trees with ultramarine blue, burnt sienna, yellow ochre, and white. More white is added to this mixture to strengthen the lighted sides of the small trunks and also the big trunk to the left. This same mixture is used to add more trunks and branches in the distance. All this work is done with the tip of a small, round, softhair brush that also picks up more of the foliage mixtures to suggest the dried leaves of a bush at the foot of the large tree. A few strokes of this coppery tone are dry-brushed over the shadow to the left of the big tree. And the tip of the brush adds a few flecks of this color to the right foreground, suggesting fallen leaves. Here and there among the foliage, a thick, pale mixture of ultramarine blue, white, and a little naphthol crimson appears to suggest pale sky breaking through the dense forest. The texture of the bark on the big tree is completed with dark, slender lines of ultramarine blue and burnt umber, drawn with the smallest round brush. By the time the picture is finished, it's almost entirely covered with opaque color. Only the glow of golden light breaking through the forest to the right of the big tree is the original transparent wash. And this remains the most luminous spot of color in the painting.

Step 1. The preliminary pencil drawing is extremely simple, defining the zones of light and dark with wandering horizontal lines. Then a flat bristle brush picks up a mixture of Hooker's green and burnt sienna and brushes this dark tone across the horizon with some long horizontal strokes, plus some short vertical ones. The color is thick and opaque, roughly indicating the trees at the horizon, without any detail.

Step 2. A mixture of ultramarine blue, yellow ochre, and burnt sienna is diluted with water to a very fluid consistency. The underlying tone and texture of the meadow are painted by tapping the flat side of a bristle brush against the painting surface, which is a sheet of illustration board. The brush is held almost parallel to the painting surface, with the tip pointing toward the sky and the end of the brush handle pointing to the bottom of the painting. The "taps" are applied in a series of horizontal rows, one below the other, until the entire meadow area is filled with ragged, horizontal bands of brush marks. As you can see, each "tap" leaves the imprint of the bristles.

Step 3. When the meadow is dry, a very pale mixture of burnt sienna and yellow ochre—mostly water—is brushed over the grassy texture to add warmth. Then the sky area is brushed with clear water. A large, flat sable is used to brush in a mixture of yellow ochre and water, which blurs and spreads softly over the wet surface. When the wash of yellow ochre is dry, the process is repeated with blue. The sky is brushed with clear water; then a large, flat sable brush "floats" on a mixture of ultramarine blue, phthalocyanine blue, and water. The blue starts at the top of the picture, spreads softly, but stops just short of the horizon, where a "blush" of yellow remains.

Step 4. The point of a small, round softhair brush adds stronger lights, darks, and details to the grass and weeds. The point of the brush scribbles up and down with a mixture of cadmium red, yellow ochre, and ultramarine blue to make row after row of dark strokes, smaller and less distinct in the distance, larger and more distinct in the foreground. Adding a bit of white to this mixture, the tip of the brush scribbles rows of lighter strokes between the dark ones. This same mixture is used to paint the rocks: more white for the lighted tops and less white for the shadows. A few strokes are added beneath the distant trees. Here and there, the warm, transparent undertone still shines through.

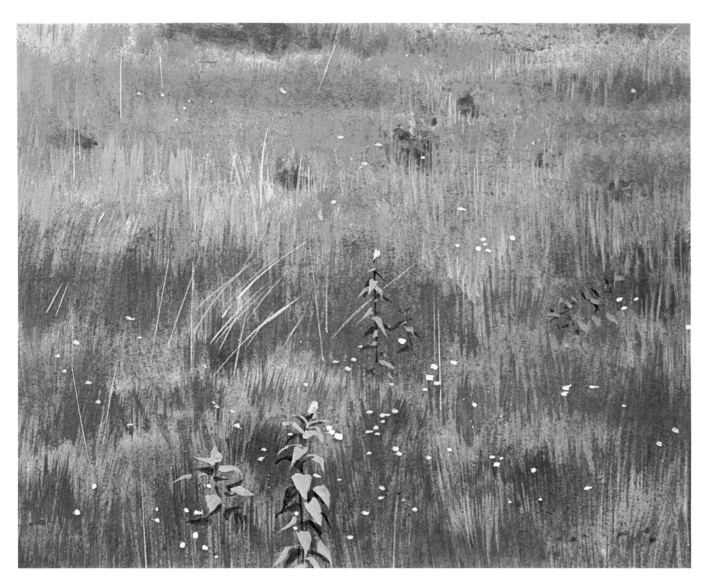

Step 5 (close-up). This close-up of the finished painting shows how the color of the grass is enriched—in the final stage—with a transparent glaze of burnt sienna, Hooker's green, water, and some gloss medium to keep the mixture from becoming too watery. This glaze adds an extra note of warmth to the tone of the meadow. When this warm tone dries, some of the greener patches are brushed with a transparent glaze of chromium oxide green, water, and a little gloss medium. The shadowy patches of grass are then strengthened with an opaque mixture of cadmium red, ultramarine blue, and white. In this final stage, a few individual blades of grass are picked out with the point of the smallest, round softhair brush, carrying a pale, opaque mixture of chromium oxide green, yellow ochre, white, and enough water to make the strokes fluid and precise. The lighted tops of the leafy weeds in the foreground are painted with this same mixture, which is darkened with ultramarine blue to paint the shadowy leaves beneath. The more distant clumps of weeds are painted with phthalocyanine green, burnt sienna, yellow ochre, and white. And the scattered wildflowers are painted with specks of white tinted with a touch of yellow ochre plus an occasional dab of pure cadmium yellow.

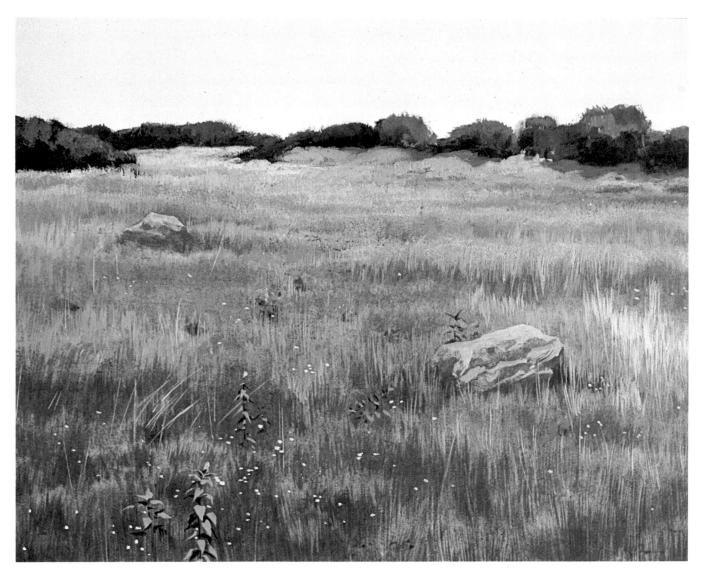

Step 5. In this final stage, a bristle brush lightens parts of the trees by scrubbing on a thick, opaque mixture of yellow ochre, ultramarine blue, burnt sienna, and white. This gives the trees a pattern of light and shadow and makes them look more three-dimensional. It also softens the bright tone with which the trees were originally painted in Step 1. Some shadows are painted under the trees with cadmium red, ultramarine blue, and white. Next to these shadows, sunlit areas are indicated with thick strokes of yellow ochre, just a little burnt sienna and ultramarine blue, plus lots of white. To strengthen the effect of sunlight on the meadow, strokes of this mixture are scribbled over the lighter patches of meadow, between the rows of shadow strokes. The rocks are glazed with a pale, transparent tone of burnt sienna, yellow ochre, and a little ultramarine blue. This landscape is an effective combination of opaque and transparent color. The sky is clear and transparent, which is just right for the subject. The distant trees are thick and opaque. The transparent undertones of the meadow still shine through in many places, particularly in the foreground between the patches of darker weeds. But this transparent undertone has been lightened, darkened, and enriched with strokes of opaque color. Note how much variety this simple subject now contains: an intricate pattern of light and shadow; a variety of lively brushstrokes; and a rich pattern of sunny and subdued colors in alternating bands.

Step 1. The pencil drawing—on a sheet of illustration board—defines not only the shapes of the various peaks, but also traces the details within these peaks. These lines record the complicated pattern of light and dark shapes that will appear in later steps. Then the sky is roughly covered with a mixture of phthalocyanine blue, ultramarine blue, white, and just enough water to make a mixture that is milky and semi-opaque so that the pencil lines will shine through. This combination of the two blues is worth remembering. Phthalocyanine blue may be too bright for the sky, while ultramarine blue can be too subdued. When you blend them and add white, you get the perfect compromise.

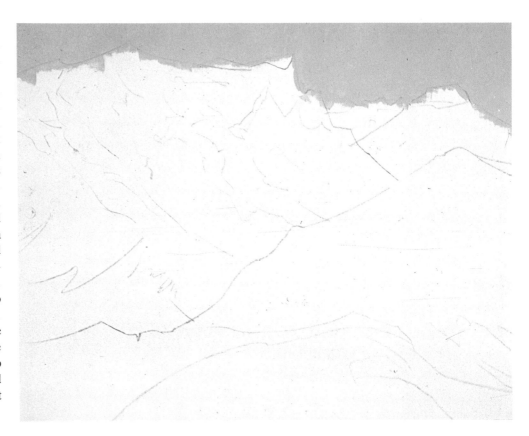

Step 2. The darker tones of the distant mountains in the upper right are painted with a blend of burnt sienna, ultramarine blue, and white. The strokes are made with a flat softhair brush, pulled downward and quickly lifted to leave an effect something like drybrush. Then a touch of this mixture is added to a great deal of white to paint the snowy peak with the point of a round softhair brush.

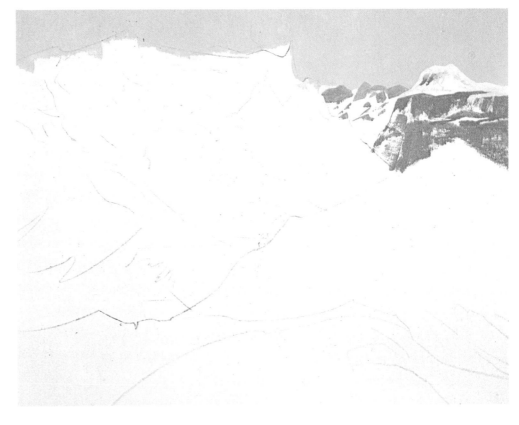

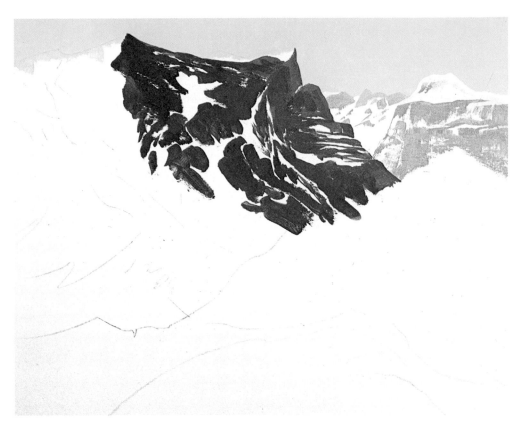

Step 3. The darks of the tallest mountain are brushed in with a mixture of burnt umber, ultramarine blue, a little cadmium red, and some white. The paint is thinned with water and a little gloss medium to a creamy consistency; thus the flat nylon brush carries the paint across the board in smooth, solid strokes. Between the strokes, strips and patches of bare paper are left to suggest the snow. Now you can see why the preliminary pencil drawing is so important: the beauty of the mountain depends on that intricate design of lights and darks, which must be followed carefully with the brush.

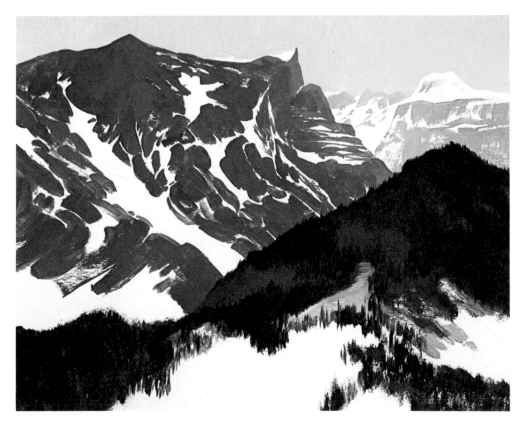

Step 4. The remaining slopes of the high mountain are painted with the same mixture used in Step 3: burnt umber, ultramarine blue, a little cadmium red, and white. Throughout, the paint is kept thick and creamy. Then the dark shape of the tree-covered mountain in the foreground is brushed in with that same mixture, containing less white. When the dark tone dries, a small, flat nylon brush scribbles in the suggestion of trees with up-and-down strokes of burnt umber, ultramarine blue, cadmium red, and yellow ochre. The shadows on the snow are the same mixture used for the distant mountains, but with more white. And the sunlit patches of snow are still the bare painting surface.

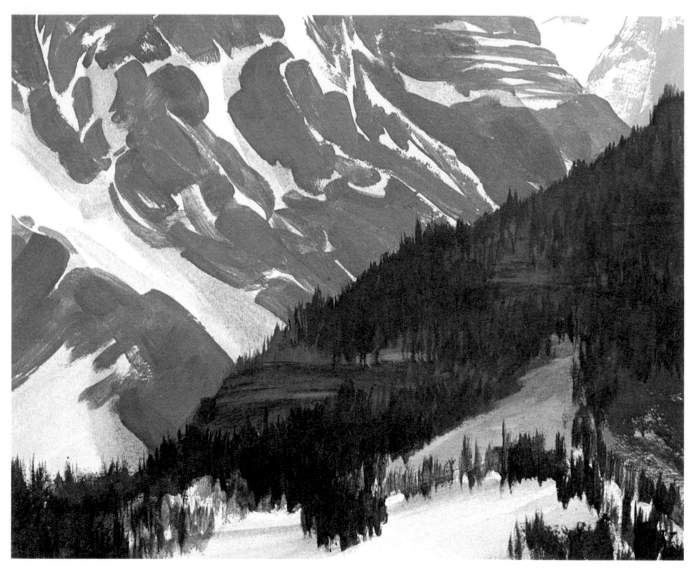

Step 5 (close-up). This life-size section of the finished painting shows the various kinds of brushwork used to paint the mountains, snow, and trees. The dark shapes of the rocks peeking through the snow on the slopes are painted with straight and curving strokes of a flat brush. The strokes follow the diagonal contours of the mountainside. The layered rock formations in the upper right are painted with horizontal strokes. The pine forest on the shadowy slope of the mountain in the foreground is painted with the point of a round softhair brush that moves up-and-down with a scribbling movement. You can't really pick out the form of any single tree, but the scribbling strokes cluster together to suggest hundreds of evergreens. The shadows on the snow are also painted with form-following strokes that move up the steep, diagonal slopes of the rocky mountainside, but move in a more horizontal direction on the snowy slopes of the mountain in the foreground, which is less steep.

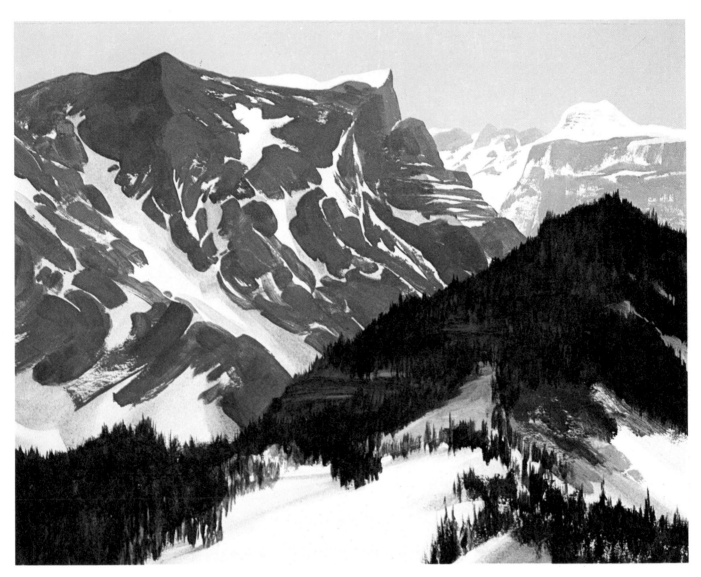

Step 5. The shadows on the snow are glazed with a transparent tone of ultramarine blue and cadmium red, plus a good deal of water and a little painting medium. The job is done with a flat softhair brush. It makes sense to use transparent color to paint the transparent shadows on the snow. Among the trees of the dark mountain in the foreground, a small, round softhair brush paints some traces of shadow with ultramarine blue, cadmium red light, and white. This brush picks up some pure white to paint a snowy shape along the topmost edge of the tall mountain. Pure white is also used to "trim" the lower edges of some of the tree strokes in the foreground, giving the impression that the trunks are growing out of thick snow. Finally, the tip of a small, round softhair brush adds tiny strokes of dark color— burnt umber, ultramarine blue, yellow ochre, and a whisper of white—to the silhouette of the pine forest, suggesting individual trees that stand up clearly against the paler mountains beyond.

Step 1. The hills will be covered with dense foliage, but there's not much point in trying to draw all those little trees. The pencil drawing defines the overall shapes of the hills and the land beneath, which will be divided into strips of light and dark. The blues between the clouds are first brushed in with a mixture of ultramarine blue, phthalocyanine blue, and white. While this blue tone is still moist, a touch of burnt sienna is added to this mixture—and then the shadows of the clouds are brushed in. The thick, creamy, opaque color of the shadows tends to merge slightly with the opaque color of the undertone. The effect is a soft, lovely fusion of the two colors.

Step 2. At the end of Step 1, the sunlit areas of the clouds remain bare white. Now the whites of the clouds are scumbled with a mixture of white plus the slightest touch of burnt umber and phthalocyanine blue. This is done with a flat nylon brush, which reshapes the clouds, the shadows, and the patches of blue sky. Now it's easier to see the forms of the clouds. The entire landscape is covered with a transparent mixture of phthalocyanine green and a little burnt sienna, plus plenty of water. The tone is painted with a big, flat brush, leaving obvious brushstrokes that will soon be covered with opaque color. The strokes contain more water in the lighter area at the foot of the hills.

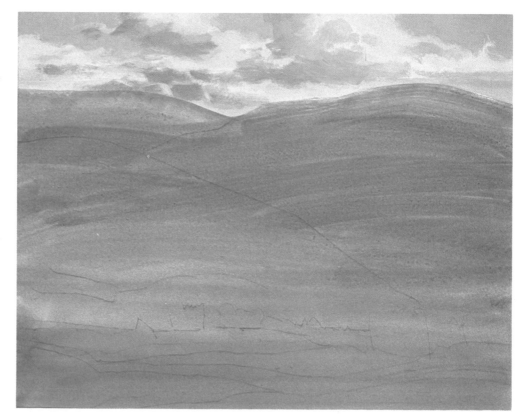

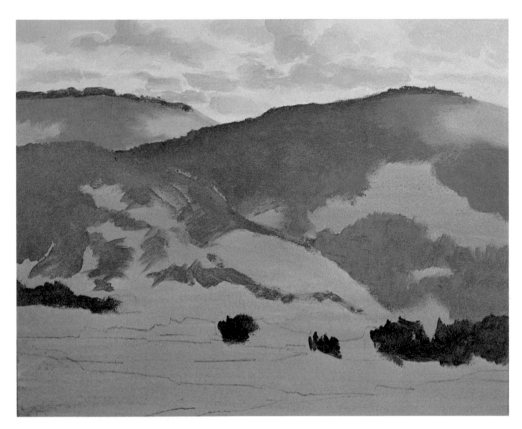

Step 3. The dark areas of the hills are scrubbed in with a bristle bright that carries an opaque mixture of ultramarine blue, Hooker's green, yellow ochre, naphthol crimson, and white. (Notice that this is one of those rare times when four colors are needed to get exactly the right mixture.) This same color, minus the white and the yellow ochre, is used to brush in some rough strokes for dark trees at the crests of the hills and on the landscape below. The light patches toward the tops of the hills are the same mixture as the shadows, but with more white and yellow ochre—scumbled with a bristle bright to blend into the edges of the shadows.

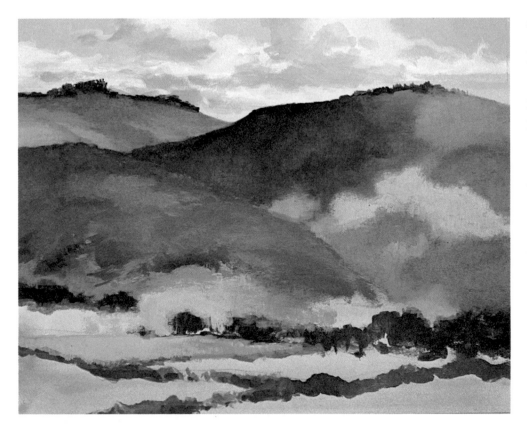

Step 4. Stronger darks are added with ultramarine blue, Hooker's green, burnt sienna, and a hint of white. Stronger lights are added with Hooker's green, burnt sienna, plus a lot of yellow ochre and white. The glowing tone at the foot of the hills, just left of center, is the same mixture, plus cadmium yellow. Rich, cool notes are added with phthalocyanine green, burnt sienna, and yellow ochre. And the darks of the foreground are added with phthalocyanine green and burnt sienna. The subtle gradations on the hillsides are all scumbled with bristle brushes.

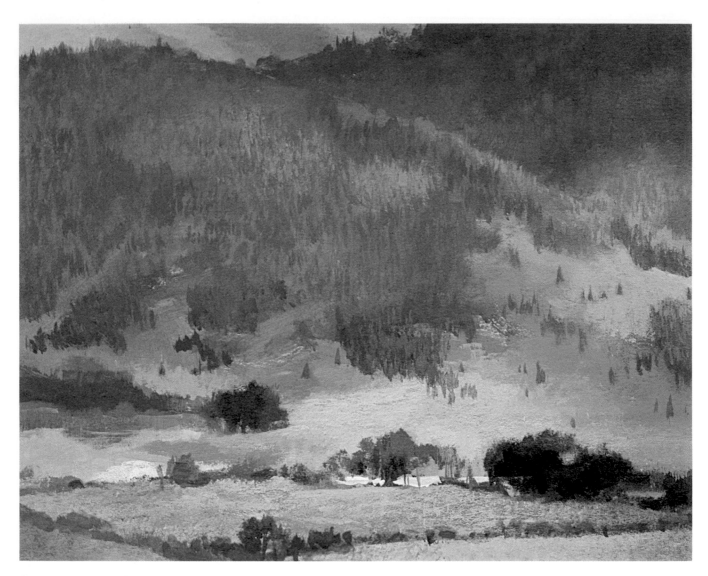

Step 5 (close-up). Here's a close-up of a section of the finished painting, showing the variety of brushwork that suggests much detail without every tree having been painted. The lights and shadows on the hillsides are all scumbled with thick, opaque color. Notice how the areas of sunlight and shadow in the lower right seem to blend softly together. That's the effect of that back-and-forth scumbling motion, which softens the edges of the brushstrokes so they seem to melt away into the color alongside them. When these scumbles are dry and won't be disturbed by further brushwork, the tip of a round softhair brush suggests those masses of trees with the same up-and-down scribbling mo- tion that is used to paint the pines in the mountain demon- stration you saw a moment ago. In some areas, the tree strokes are close together, suggesting dense growth. At other points, the tree strokes are farther apart, suggesting sparse growth. But the tree strokes never completely cover the scumbled undertones—which render the lights and shadows on the hills and make the big, rounded forms look three-dimensional. The triangular shapes of the individual evergreens, standing alone here and there, are painted with a single touch of the point of the round brush, pressing down slightly to make the brush spread at the bottom of the stroke.

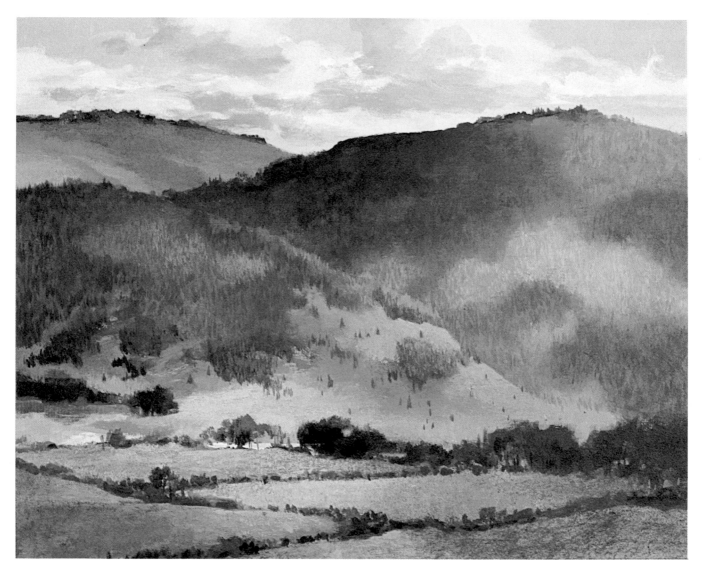

Step 5. When you look at the complete painting, the small, scribbly strokes of the dark trees merge and melt away into the shadow sides of the hills. These tree strokes are a mixture of ultramarine blue, naphthol crimson, yellow ochre, and a hint of white. In some of the sunlit areas of the hills—particularly to the right—sunstruck foliage is suggested with the same kind of brushwork. But these strokes are light mixtures of chromium oxide green, cadmium yellow, and white, with the warm undertone still shining between them. The light and dark mixtures on the hillsides are also scumbled over the fields in the foreground. The forms of the trees at the foot of the hill, as well as the hedges between the fields, are sharpened up with small strokes of burnt sienna, Hooker's green, yellow ochre, and a little white. The tip of the brush adds some trunks to the trees. An occasional warm note appears among the trees to relieve all that green—a mixture of cadmium red, burnt sienna, and a little ultramarine blue. At the crest of the hill to the left, the trees poke too far up into the sky, so they're trimmed down with a few strokes of sky tone. The painting has come a long way from the uniform green of Step 2. These hills are now a rich tapestry of color, warm and cool, dark and light.

Step 1. These desert rocl formations and their sandy surroundings are painted on smooth watercolor paper. The rocky forms are complicated, so the pencil drawing records them as precisely as possible. The pencil traces not only the outer edges of the rock formations, but the planes of light and shadow that will make the forms look three-dimensional. The cloud forms and the shapes of the sandy foreground are drawn more freely.

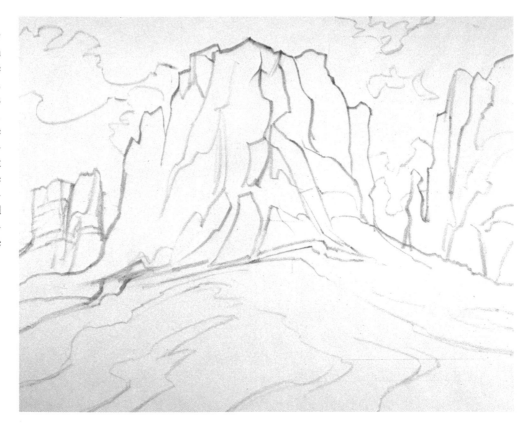

Step 2. The pencil lines are lightened with an eraser and are practically invisible. The sky is painted with a transparent wash of ultramarine blue, phthalocyanine blue, and water, carried around the rock formations. The shadow side of the big shape is painted with ultramarine blue, naphthol crimson, and water. Cadmium red, ultramarine blue, and water are freely brushed over the lighted side and blended into the wet shadow tone. This same warm mixture is brushed over the rocky shape to the right. Then a little white and a lot of water are mixed with the shadow tone, which is brushed over the foreground and over the edge of the rocky shape.

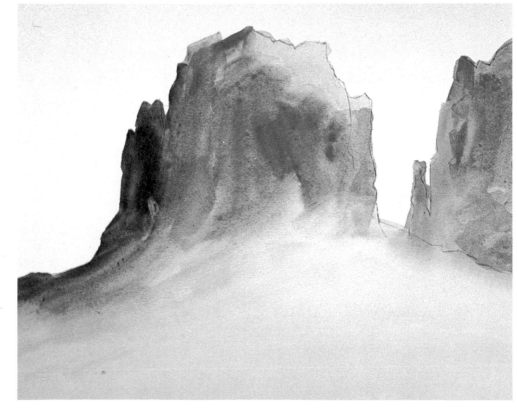

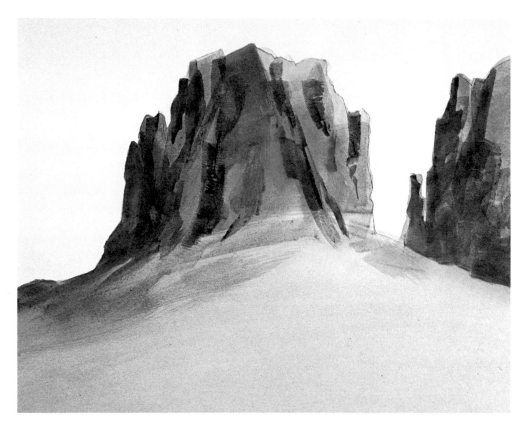

Step 3. When Step 2 is dry, a flat softhair brush picks up the same shadow mixture—ultramarine blue, naphthol crimson, and less water—to paint the shadows with squarish strokes. When these strokes are dry, a darker wash of cadmium red and ultramarine blue (containing less water) is carried over the rocks with the same brush. At this stage, there are clearly defined planes of light and shadow on the two big rock formations, creating a feeling of strong sunlight striking the rocks from the right. A bit more of the shadow mixture is brushed along the sand at the base of the biggest rock.

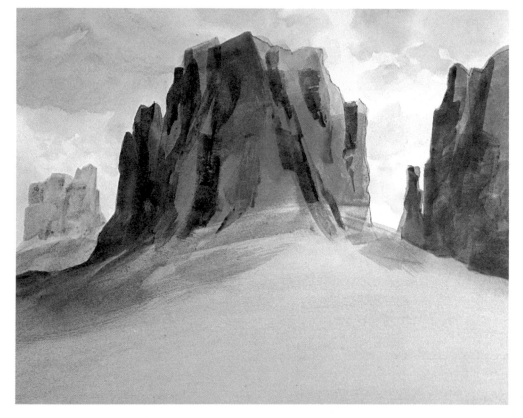

Step 4. At the end of Step 3, the sky is still the very pale blue that was applied at the very beginning. Now deeper blues are added with a round softhair brush: ultramarine blue, plus a little naphthal crimson and yellow ochre and a lot of water. Alongside these wet patches, the same brush brings in shadowy tones of the same mixture— with more crimson and less blue—to blend wet-in-wet with the blue shapes. Here and there the brush softens the edges of the wet shapes with clear water, as you can see most clearly in the upper right. The distant rock formation at the left is painted with the shadowy sky mixture— more water on the lighted side and less on the shadow side.

Step 5. A touch of white is added to each of the sky mixtures—the blue and the shadow tone—making them more opaque. Then these mixtures are scumbled over the sky area in the upper left, still leaving the sky in the upper right untouched. The cloud behind the small rock formation at the left is scumbled with white tinted with just a little ultramarine blue and naphthol crimson. The curving contours of the sandy foreground are suggested with scrubby strokes of cadmium red, ultramarine blue, yellow ochre, and white. A few touches of this mixture are added to the sunlit planes of the biggest rock formation.

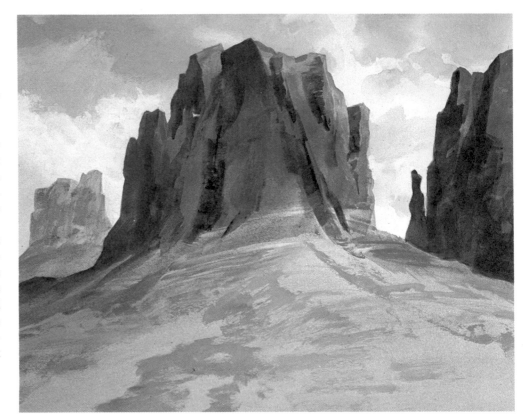

Step 6. Strong shadows are added to the bigger rock formation with square strokes made by a flat softhair brush. These darks are a mixture of ultramarine blue, cadmium red, and a little water. The point of a round softhair brush draws some crisp lines over the rocks to suggest cracks and crevices. A touch of white is added to this mixture for the shadow that's carried across the left. A few strokes of the sandy tone—cadmium red, yellow ochre, and white—are carried up into the base of the center rock.

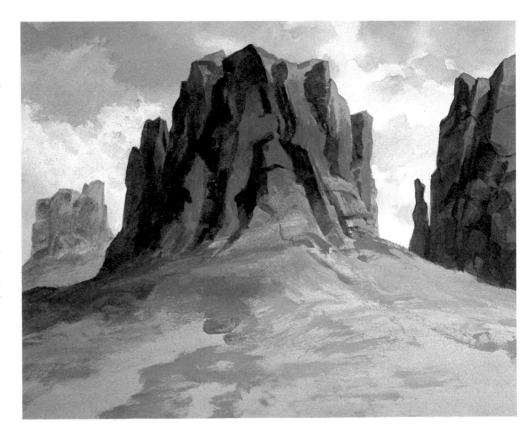

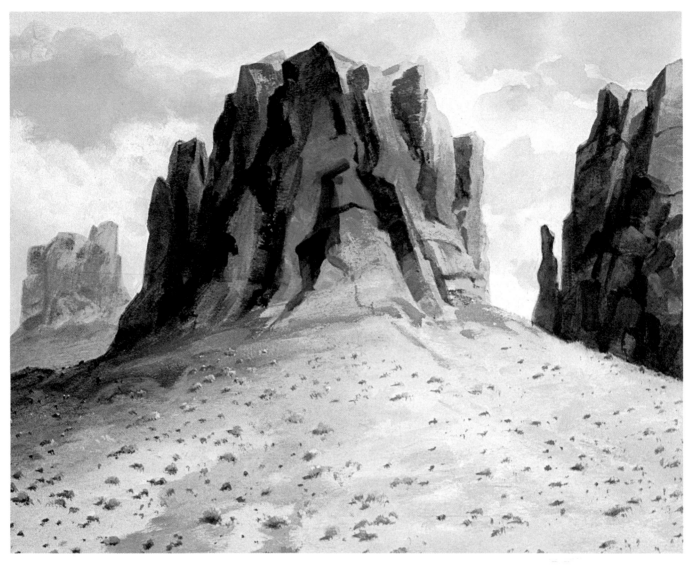

Step 7. Now is the time to simplify some of the major areas of the picture before going on to the final details. The sky behind the big rock formation looks a bit too dark; the rock will stand out more strongly against a lighter sky. So a pale, opaque mixture of ultramarine blue, naphthol crimson, phthalocyanine blue, and white is scumbled around the big, ruddy shape to make the sky drop back slightly. Too much seems to be happening in the sandy foreground, so this is scumbled with various mixtures of naphthol crimson, cadmium red light, yellow ochre, cadmium yellow, ultramarine blue, and white—never more than three or four of these colors to a mixture. These sandy tones obliterate a lot of the distracting brushwork that you saw in Step 6, producing a slightly smoother tone. The last details are those small touches of green that suggest the desert weeds. These are nothing more than little dabs made by the tip of a bristle brush carrying a thick, not-too-fluid mixture of chromium oxide green, yellow ochre, and white. The touches of dark shadow under these weeds are the same mixture used for the shadows on the rocks: ultramarine blue, naphthol crimson, and a hint of white. These touches of shadow are often placed slightly to the left of the green strokes, reinforcing the feeling that the strong sunlight comes from the right. One strong shadow remains in the foreground, just left of center, subtly leading the eye upward toward the central rock formation. Once again, this landscape is an effective combination of transparent and opaque color. The most brilliant, luminous colors on the rocks are transparent washes, thinned only with water. The softer colors of the foreground are opaque. The sky is painted in transparent color at the beginning, but opaque color is added for certain necessary corrections.

Step 1. The painting begins with a pencil drawing on a sheet of illustration board. Burnt sienna, ultramarine blue, and water are mixed on the palette to a very fluid consistency. A roughly textured synthetic sponge is soaked in clear water; then most of the water is squeezed out, leaving the sponge moist. One flat side of the sponge is dipped into the pool of color on the palette. Then the sponge is carefully pressed against the surface of the illustration board and lifted away, leaving a mottled pattern that suggests the texture of the rocks in the stream. Just one area—in the upper right—is scrubbed in with a brush, since this is a reflection, not a rock.

Step 2. A large, flat softhair brush scribbles in the tones of the trees with a mixture of Hooker's green and burnt umber, diluted only with water so that the color is transparent. More water is added for the lighter areas. The marks of the brush are left to suggest the texture of the leaves.

Step 3. Still working with very fluid, transparent color—the consistency of watercolor—the brush adds the cool tones of the stream with ultramarine blue, burnt umber, and yellow ochre. The color is diluted only with water. Notice how the strokes seem to follow the movement of the water rushing between the rocks. Gaps of bare paper are left to suggest foam. Just below the distant shoreline, the brush scrubs in some of the tree mixture—the same colors used in Step 2—for reflections. So far, all the work is done with round and flat softhair brushes.

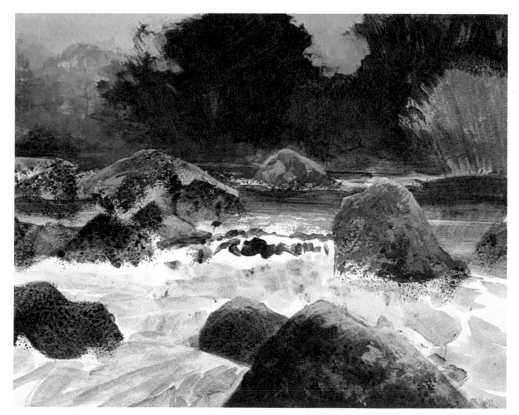

Step 4. Now the first opaque color appears. The sky is painted with rough strokes of ultramarine blue, burnt sienna, yellow ochre, and white. These strokes reshape the edges of the trees, enlarging the patches of sky. This same mixture, containing less white and a little more burnt sienna, is scumbled over the distant trees to the extreme left; now they seem farther away. The rocks are glazed with a transparent wash of burnt sienna, Hooker's green, water, and a little gloss medium, deepening their tone while still allowing the underlying texture to come through. When this glaze is dry, the brush picks up some pale sky color and scumbles it over the lighted tops of the rocks.

Step 5. The rocks at the left seem too scattered, so now they're pulled together. The dark tone of the rock in the lower left is extended upward with another sponge mark. The sky tone is scumbled over the other rocks at the left, making them one big rock formation and covering up the patch of water. Then the foam patterns are painted with white, tinted with a touch of sky tone. The broad strokes are made by a flat softhair brush, while the slender lines are made with the tip of a round brush. The lines follow the flow of the stream. The solid patches of foam are dense and opaque. But the other white strokes are semi-opaque, revealing the cool undertones.

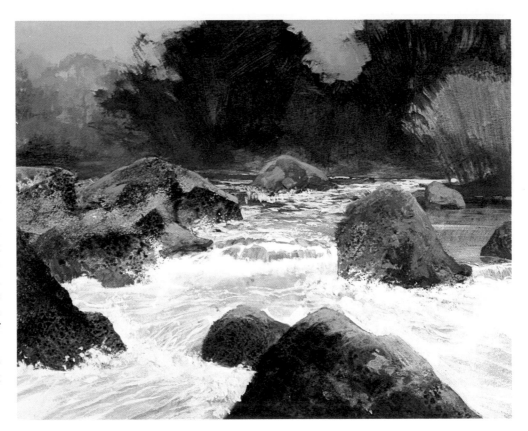

Step 6 (close-up). This section of the final painting shows how different kinds of brushwork combine to create the various textures of rocks and water. The shadow tones of the rocks clearly show the mottled marks of the sponge. Over this transparent color, the brush deposits short, thick strokes of opaque color to accentuate the lights. The cool, transparent undertone of the water shines through the opaque and semi-opaque strokes of the foam. The foam is painted with short, thick dabs where it's most dense, small dots to suggest flecks of foam splashing upward, and slender lines where the foam trickles over the dark water.

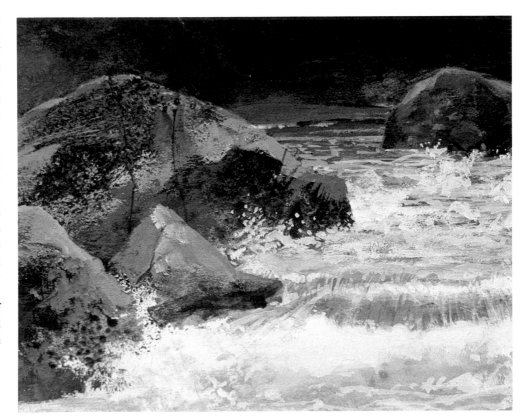

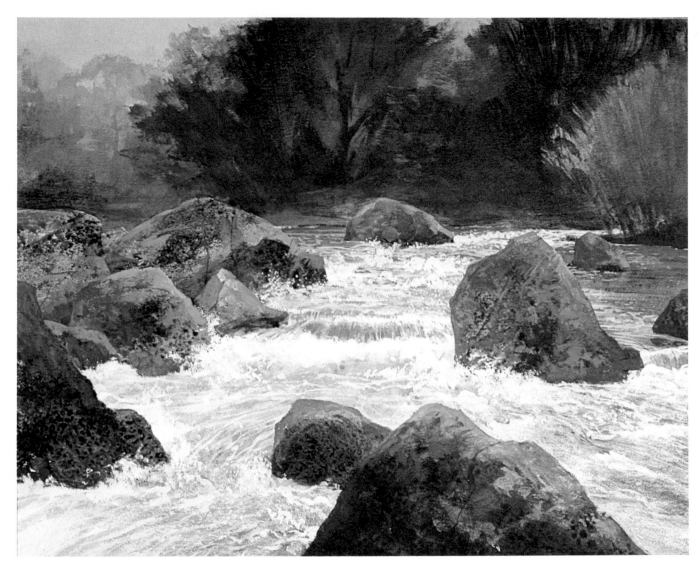

Step 6. The water is completed with many small, semi-opaque lines of white—tinted with sky color—that methodically follow the flow of the stream around and between the rocks. The cool, underlying tone, applied in Step 3, is never completely covered; it's this combination of transparent color beneath and semi-opaque color above that gives the water that special luminosity. A few more touches of sky tone are scumbled over the tops of the rocks and allowed to dry. Then the point of a small, round softhair brush draws a few cracks on the sides of the rocks. Final adjustments are made to the trees. A bit of opaque sky color is mixed with the original tree tone—making the mixture more opaque—and the darks of the trees are extended to narrow the patch of sky that breaks through the trees just to the right of center. A little sky tone is scrubbed into the middle of the big tree at the center of the picture and allowed to dry; then a trunk and some branches are painted over this lighter tone. This painting follows a couple of "rules" that can be helpful, though they shouldn't be followed rigidly. First, a good way to paint a landscape is to start with transparent color and then finish with opaque color. Second, when you combine transparent and opaque color, try to keep your shadows transparent and save your opaque strokes for the lights.

Step 1. The pencil drawing defines the outer edges of the big, snow-covered tree, the snow-covered rocks, and the frozen stream. Equally important, the pencil lines trace the shapes of the dark rocks that appear within the snow to the left. Then a bristle brush scrubs a thick, opaque mixture of ultramarine blue, burnt sienna, cadmium red, and white over the sky. The sky is dim and overcast, but some light comes through to the left of the big tree. This tone contains less ultramarine blue and more white.

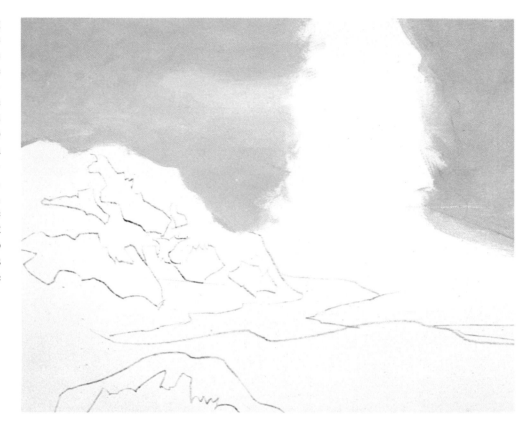

Step 2. The dark patches of rock, so carefully drawn in Step 1, are now painted with a blend of ultramarine blue, burnt sienna, and white. The color isn't too thoroughly mixed on the palette. Nor are the strokes blended together on the painting surface—a sheet of illustration board. So these strokes have a ragged, irregular texture, like that of the rocks. The snow-covered branches on either side of the tree are painted with wavy strokes of white, tinted with a little sky tone.

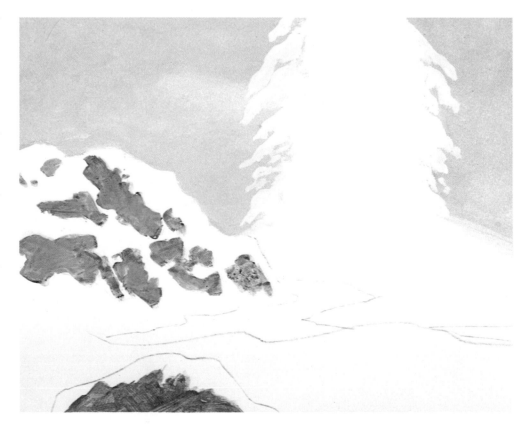

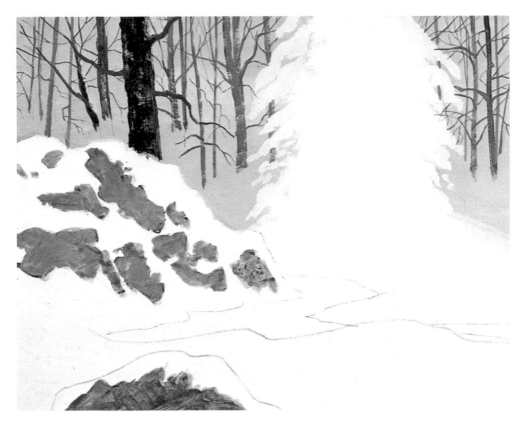

Step 3. The trunks and branches of the distant trees are painted with a mixture of ultramarine blue, cadmium red, yellow ochre, and white. The thicker trunks are painted with a flat softhair brush, while the thinner trunks and branches are painted with a round softhair brush. The paint is thick and creamy, so it doesn't flow too smoothly over the painting surface; the result is an effect something like drybrush, which you can see most clearly in the trunk of the dark tree. As the trunks grow more distant, more white is added to the mixture.

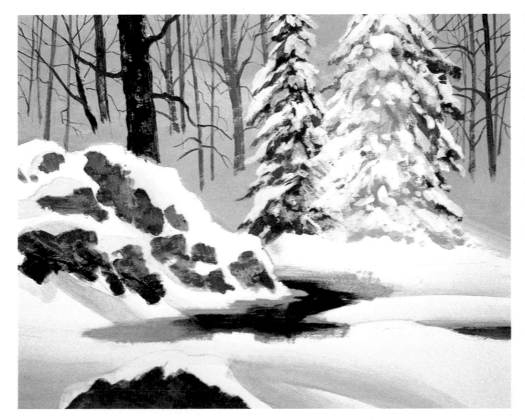

Step 4. The original sky mixture is thinned with more water to paint the shadows on the snowbanks with transparent color. The edges of these shadow strokes are softened with clear water. The rocks are darkened with a thick mixture of ultramarine blue, burnt sienna, yellow ochre, and white. This same mixture, with a little more white, is used to paint the pale edges of the frozen stream, while a darker version is used to paint the deepest tones. A few strokes of sky color divide the big tree shape in two. Strokes of rock tone suggest shadowy branches. Then strokes of white, tinted with sky color, represent the clumps of snow resting on these branches.

Step 5. More strokes of white, tinted with a little sky tone, are added to thicken the snow on the trees. The shadowy band of trees at the horizon is scumbled in with ultramarine blue, cadmium red, yellow ochre, and white, partially obscuring the bases of the treetrunks. Snowbanks are added beneath the horizon and between the trees with more sky mixture and white. The edges of the snowbank to the left are sharpened with pure white toned with the faintest touch of sky color.

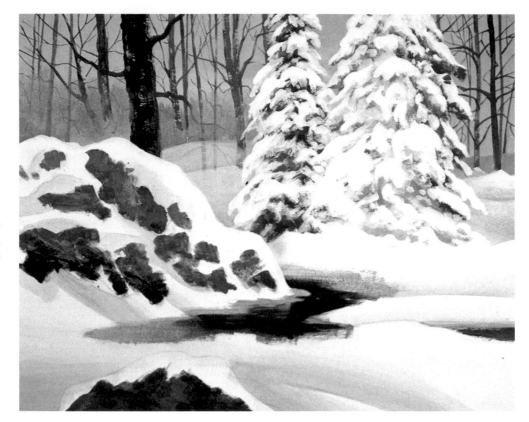

Step 6 (close-up). In the finished painting, the solid patches of snow on the rocks and branches are painted with thick strokes of creamy, opaque color. The darks of the rocks and branches, showing through the snow, are done with thinner, more fluid color. The dark tones of the frozen stream are painted in the same way. Then a bit of the snow color, tinted with sky tone, is scumbled over the dark strokes of the rocks and branches here and there. This same color is thinned with water to paint the reflection of the snowbank in the frozen stream; these semiopaque strokes allow the darkness of the stream to shine through.

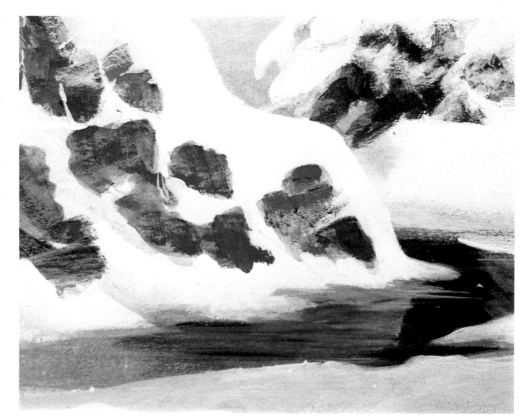

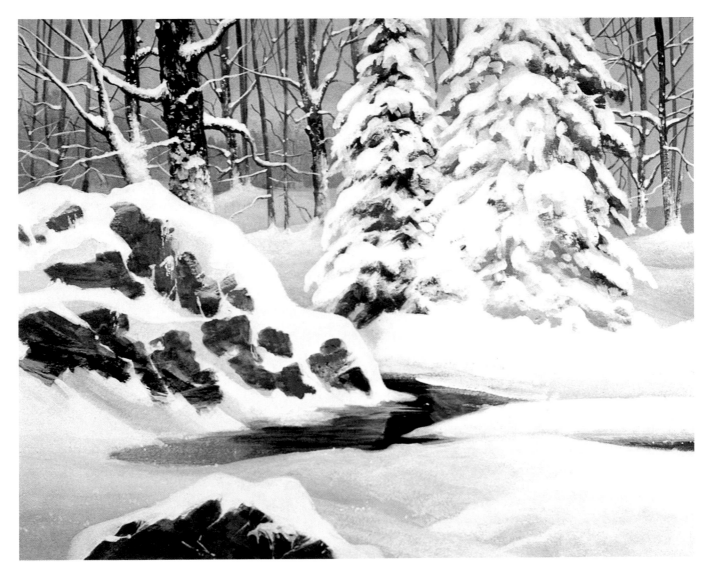

Step 6. The distant treetrunks are reinforced with thick strokes of burnt sienna, ultramarine blue, yellow ochre, and white. When these strokes are dry, snow is dabbed on the trunks and branches with thick white tinted with a little ultramarine blue and applied with the tip of a small bristle brush. The point of a round softhair brush draws snowy lines on the tops of the thinner branches. A large bristle brush scumbles this same bluish-white mixture over the sunlit portions of all the snowbanks in the middle distance and the foreground. The back-and-forth scrubbing stroke blends the pale tops of the snowbanks into the darker shadow planes. Thick strokes of this snowy mixture are carried over the top of the dark rock in the left foreground. A few touches of snow are drybrushed over the dark shapes of the rocks. The tip of a round brush paints a few light lines on the rocks to suggest snow that's settled in the cracks. Pure white is mixed on the palette with lots of water. A big bristle brush—or perhaps a toothbrush—is dipped into this milky fluid. Then a stiff piece of wood, such as a brush handle or an ice cream stick, is drawn over the tips of the bristles to spatter a few snowflakes over the foreground. You can see them clearly in the lower left. Notice how the warm sky tone, which you first saw in Step 1, remains behind the trees, just above the horizon.

Step 1. The preliminary pencil drawing—on a sheet of watercolor paper—traces the outlines of the clouds, the shapes of the blue patches between the clouds, and the contours of the hills at the horizon. Although the contours of the clouds will change slightly, it's important to decide exactly where the clouds go. It's equally important to make sure that the clouds and the patches of sky form an interesting and varied design. The three main clouds are all different shapes and sizes. The strip of sky between the clouds is wide at some points, narrow at others, and keeps the eye interested.

Step 2. The blue shapes of the sky are painted with a mixture of ultramarine blue, phthalocyanine blue, and white at the very top of the picture. Just a little yellow ochre is added to this mixture at the center. The lower sky, right above the horizon, contains more white and yellow ochre. The clouds are just white paper at this point, but their shapes are becoming more ragged. The sky tones are freely scrubbed in with a bristle brush.

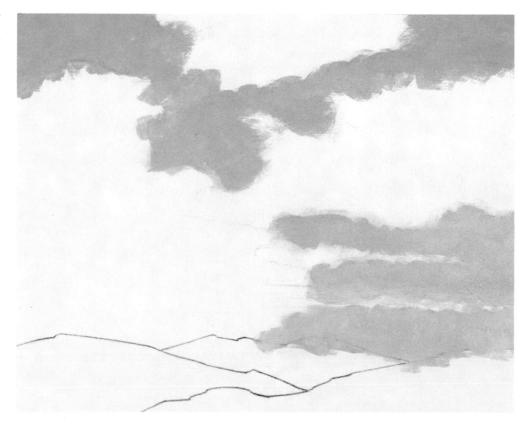

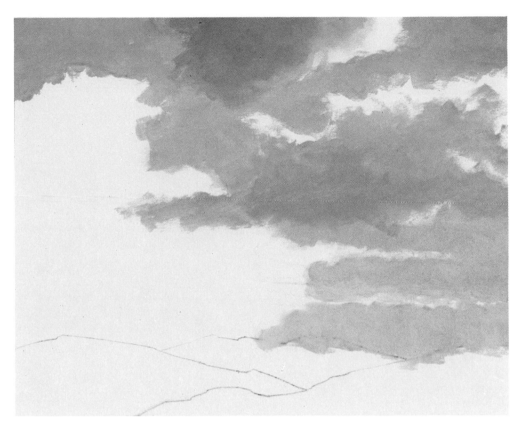

Step 3. The same bristle brush begins to scumble in the cloud shadows. This shadow tone is a mixture of ultramarine blue, cadmium red, yellow ochre, and white. Actually, you can see two distinct shadow tones. The lighter tone obviously contains more white; it's also slightly warmer, containing more cadmium red and yellow ochre. The darker, cooler tone contains more ultramarine blue. The scumbling stroke creates a soft edge where the shadow sides of the clouds seem to melt away into the blue of the sky.

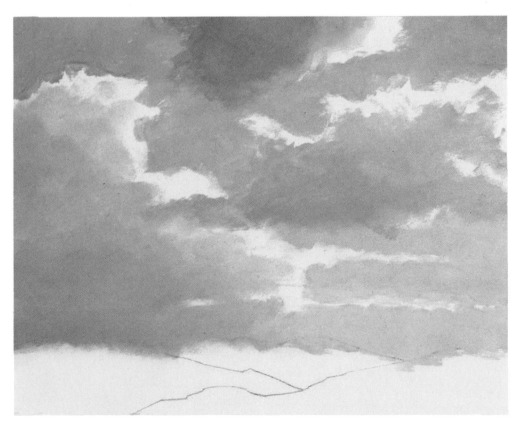

Step 4. The shadow side of the biggest cloud is painted with the same mixtures and the same scumbling strokes. The scrubbing motion of the brush creates a soft edge where the shadow side of the cloud ends and the sunlit side begins. All these sky tones are thick and opaque enough to cover most of the pencil lines.

Step 5. The clouds cast strong shadows on portions of the land below. At other points, the sun breaks through the clouds and illuminates parts of the hills. The shadow on the distant hill is painted with ultramarine blue, yellow ochre, and white—with a little more white on the lighted portion of the hill. The shadow tones on the foreground hills are ultramarine blue, yellow ochre, cadmium yellow, and white. The sunlit hill to the right is painted with phthalocyanine blue, cadmium yellow, yellow ochre, and white. The bristle brush drags thick color over the textured painting surface, leaving some flecks of bare paper for a drybrush effect.

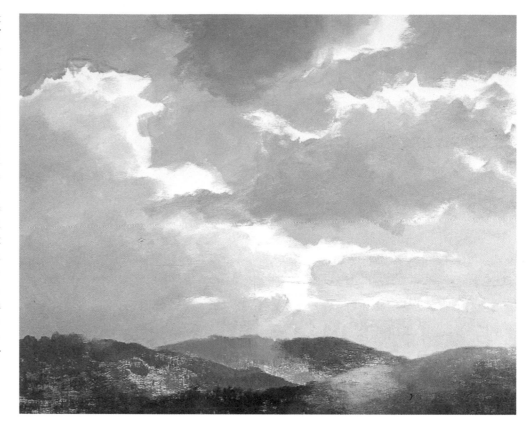

Step 6. Until now, the sunlit edges of the clouds are bare paper. Now these lights are scumbled with lots of white faintly tinted with ultramarine blue, yellow ochre, and naphthol crimson. The shapes of the clouds grow rounder and fuller. The scumbling stroke blends the lights softly into the edges of the shadows. This same stroke softens the lighted edges so they don't look too harsh and mechanical against the blue sky. Just above the horizon, several long, slender, shadowy clouds are painted with the same mixture that's used to paint the shadows in Step 4: ultramarine blue, yellow ochre, cadmium red, and white.

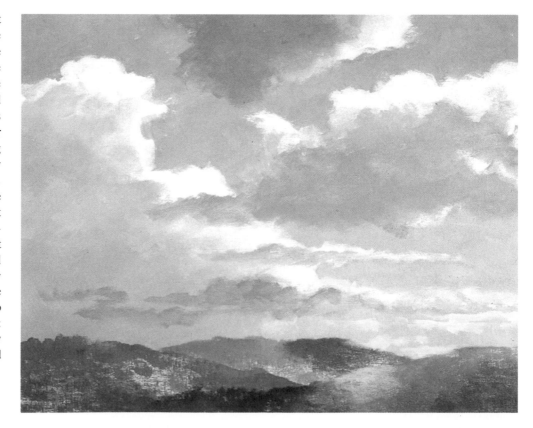

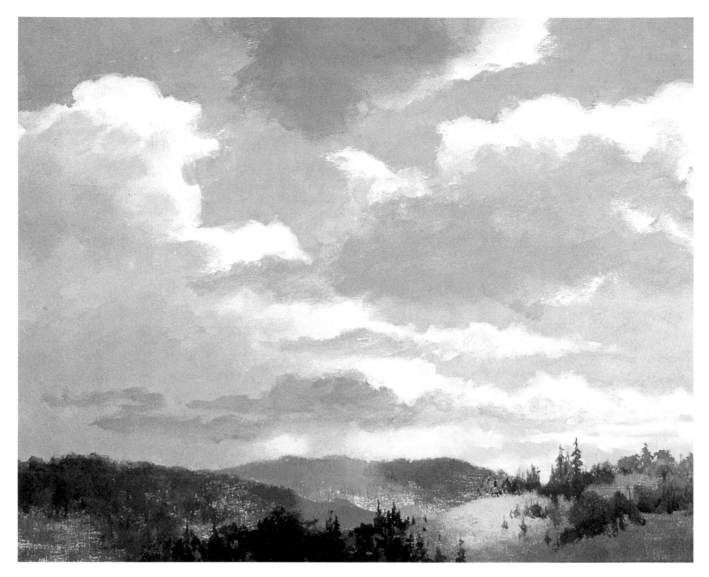

Step 7. The shadowy undersides of the clouds are strengthened and enriched with scumbled strokes of ultramarine blue, cadmium red, yellow ochre, and white. This isn't one consistent shadow tone: at some points you can see where it contains more red and yellow. At other points you can see where the shadow tone contains more blue. The individual strokes stand out more clearly than the strokes in Steps 3 and 4, when the shadow tones were first blocked in. The hill in the left foreground is darkened to strengthen the shadow cast by the clouds. A dark mixture of phthalocyanine blue, cadmium yellow, and burnt sienna is drybrushed over the top of the hill. The shadow on the distant hill is also strengthened with this mixture, which now contains a bit more white. This same mixture—now mostly phthalocyanine blue and burnt sienna—is used to paint the trees on the hilltop with small touches of a round softhair brush. This is a good example of a picture painted almost entirely by scumbling. The soft shapes of the clouds are scumbled. The soft transitions between the light and dark areas of the hills are scumbled too. Just a bit of drybrush appears in the hills to suggest some texture. Only the trees are painted with precise touches of fluid color.

Step 1. This pencil drawing defines the outer edges of the clouds, the shapes of the landscape below, and the line of the water. Then the deep, cool tones of the sky are scumbled with a bristle bright carrying a mixture of ultramarine blue, phthalocyanine blue, a touch of naphthol crimson, and white. More white is added to this mixture as the brush moves downward toward the horizon. The brush scrubs the darker and lighter strokes together to produce a subtle dark-to-light gradation. The big cloud at the center is bare paper. The smaller clouds above the horizon are strokes of white tinted with a little sky mixture. The picture is painted on cold pressed watercolor paper.

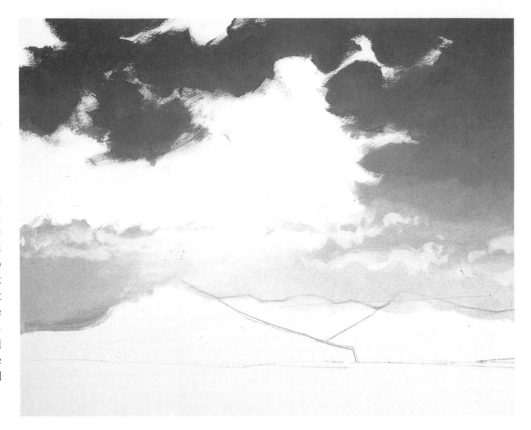

Step 2. When the sky is dry, the dark tones of the clouds are scumbled with a deep mixture of ultramarine blue, cadmium red, and just a hint of white. The back-and-forth scrubbing stroke produces soft edges where the clouds meet the sky. More white and blue are added to this mixture for the paler clouds in the lower sky. Along the bottom of the big, dark cloud, the bristle brush scumbles a mixture of cadmium red, yellow ochre, and white. Looking back at Step 1, you can see that the sky is palest directly under the sunlit edge of the big cloud; this suggests the intense light of the sun behind the cloud.

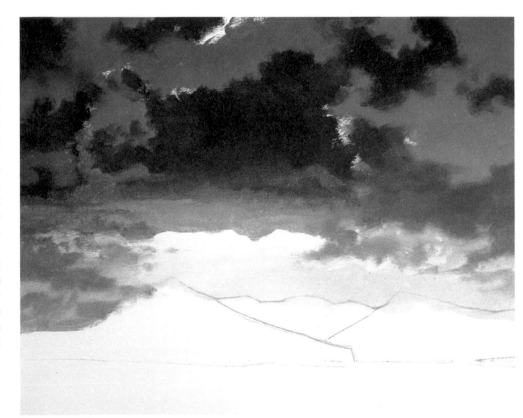

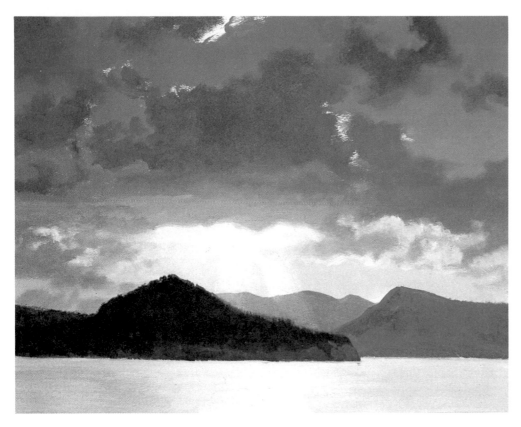

Step 3. A mixture of cadmium red, yellow ochre, ultramarine blue, and white—the consistency of cream—is brushed smoothly over the shapes of the island peaks. The most distant peak contains more white and blue; the nearest peak contains almost no white. This same mixture, containing more white and more water, is drybrushed over the band of water below the horizon, leaving some bare paper at the center to suggest the reflection of the sun. Sunlit edges are added to some of the lower clouds with strokes of thick white tinted with a speck of cadmium red, ultramarine blue, and yellow ochre. This same mixture is drybrushed downward from the center of the sky to suggest rays of light.

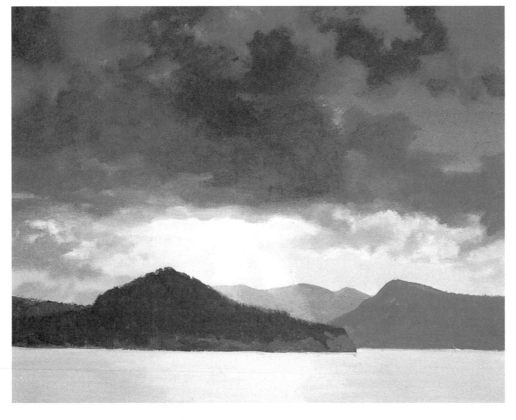

Step 4. A big, flat softhair brush glazes the upper sky with a transparent mixture of ultramarine blue, naphthol crimson, and mars black, thinned with water and gloss painting medium. Now the upper sky is darker and contrasts more dramatically with the sunlit lower sky. The dark clouds are reshaped and enlarged with scumbled strokes of ultramarine blue, cadmium red, and some white. The ruddy band at the bottom of the central cloud becomes narrower. The brilliant light of the lower sky is strengthened with pure white tinted with cadmium yellow. And the water is cooled with the same transparent glaze as the upper sky, but containing much more water here.

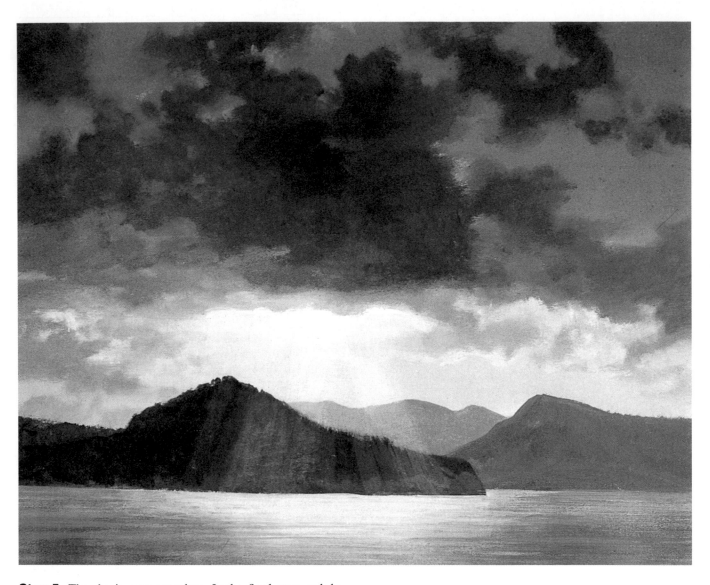

Step 5. The sky is now complete. In the final step, subtle touches are added to the islands and the water to make them harmonize with the sky. At the right and left, the water is darkened with drybrush strokes of cadmium red, yellow ochre, ultramarine blue, and white to suggest the reflections of the dark islands in the water. When these reflected tones are dry, a small softhair brush is used to drybrush thin, horizontal lines across the water. These strokes are the same combination as the dark reflections, but the proportions of the colors change from stroke to stroke. The strokes at the edges contain more blue or red. The strokes at the center contain more yellow and white to suggest the brilliant sunlight shining on the water. This same pale mixture is drybrushed with diagonal strokes over the islands to carry the sun's rays all the way down to the water. This final landscape demonstration shows three different ways to apply color: scumbling in the sky; creamy, fluid color on the islands; and drybrush in the water.

Potential Pictures. One way to tell the difference between an experienced painter and a beginner—without even looking at their work—is to watch how they find a subject to paint. The experienced artist walks for ten or fifteen minutes (maybe less), then quickly sets up his gear and gets to work. The beginner often wanders for an hour or more, looking for "just the right subject," and finally gets to work when the experienced painter is half finished. Why does the "veteran" find his subject so much more quickly? Does he just have a better eye, so he spots the "right subject" more quickly? On the contrary, he knows that he *won't* find perfect pictures, so he doesn't waste his time looking for them. He seizes on a subject that seems to have *potential*. The elements of the picture may be out there, but they're usually scattered, the wrong size, the wrong shape, or just too far away. They become a picture because the artist sees how they might be reassembled into a satisfying pictorial design. The experienced artist spends his time *creating* the painting, while the beginner wastes his time looking for it.

Looking for Potential. There are many ways to spot a potential picture. The most obvious way is to look for some big shape that appeals to you, such as a clump of trees, the reflections in a lake, a rock formation, or a mountain peak. You organize the other parts of the landscape around this center of interest, deciding how much foreground, background, and sky to include, then bring in various "supporting actors" such as smaller trees, rocks, and more distant mountains. Still another approach is to look for some interesting color contrast, such as dark blue-green evergreens against the brown trees of an autumn landscape, or the hot colors of desert rock formations against a brilliant blue sky. You might also be intrigued by a contrast of light and shadow, like a flash of sunlight illuminating the edges of treetrunks in dark woods.

Orchestrating the Picture. Having decided on a focal point, you still have to decide how to organize the various elements that make a picture. You can't just stick that clump of trees or that rock formation in the middle of the painting, include a little sky and a little background, and then go to work. Just as a famous star needs a supporting cast, the focal point of your picture needs some secondary elements. If the dominant shape in your picture is a big tree, place it a bit off center and balance it against some smaller trees—which will make the big tree look that much bigger. A mountain peak will look more imposing with a meadow and some low hills in the foreground, plus some paler, more distant peaks beyond. If those smaller trees, that meadow and hills, or those distant peaks aren't exactly where you want them, you can move them to the right spot in the picture. If they're too big or too small, don't hesitate to change their scale.

Keep It Simple. Just as you decide what to put *into* the picture, you must also decide what to leave *out*. You may actually see dozens of trees, but a big one (or a big clump) and a few smaller ones are enough to make a picture. Don't try to paint every pebble scattered at the foot of that rock formation; just a few pebbles are enough to make the big rocks look bigger by contrast. A sky is often filled with clouds, all roughly the same size and shape. They look beautiful in nature, but they make a dull picture, so enlarge one, reduce two or three others, and leave out the rest.

Make a Viewfinder. Many painters use a simple device that helps them isolate pictures within the landscape. To make a viewfinder, as it's called, take a piece of white or gray cardboard about the size of the page you're now reading. In the center of the cardboard, cut a "window" that's about 5" x 7" (125 mm x 175 mm). Hold this viewfinder at a convenient distance from your eye—not too close—and you'll see lots of pictorial possibilities that you might not spot with the naked eye. You can also make a viewfinder by making a rectangular window with the fingers of both hands, like a motion picture director might do.

Try Again. An unpromising subject often turns into a winner with a slight change in the light, the weather, or your vantage point. If you want to capture the blue of a lake at its most brilliant, the color will be strongest at midday, when the sun is brightest. But later in the afternoon, as the sun drops low in the sky, the shoreline of the lake may have a dark, mysterious silhouette, and dark ripples will appear on the surface of the water—giving you a second picture of the same subject. It's also a good idea to walk around the subject and look at it from different angles. From one vantage point, those distant hills may be framed by trees, while the hills may have a more interesting shape from another angle. One view may interest you more than the other—or you may want to paint both. Some subjects look more paintable when you move closer, such as the gnarled texture of an old tree stump, which you can't see so easily from a distance. At other times, it's best to step back: that cluster of wildflowers may merge into an interesting, irregular shape if you paint them from farther away. Keep watching. Keep moving. There are more pictures out there than you think.

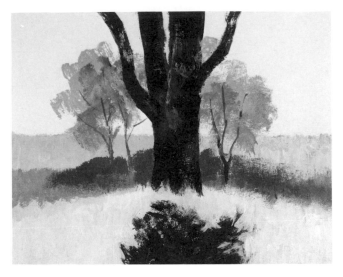

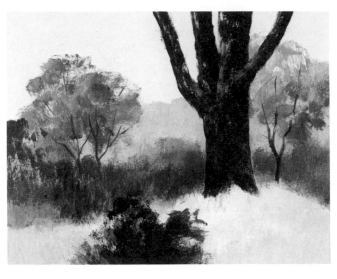

Don't split your composition into two vertical halves by running something like a tree down the center. Nor is it a good idea to split the composition into two horizontal halves by running the horizon across the midpoint as you see here. A completely symmetrical composition is boring.

Do place that tree off center and move the horizon up (or down) to divide the composition into unequal parts. Asymmetry is usually more interesting than symmetry.

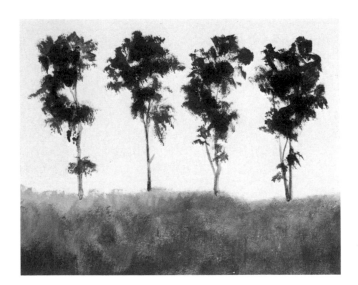

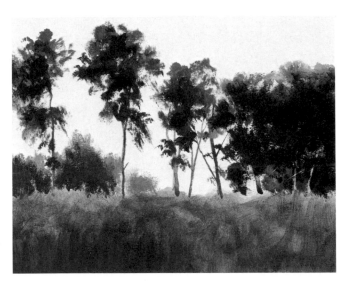

Don't space things out equally and make them all the same size, like a row of wooden soldiers. In this monotonous composition, not only are the trees all the same size and shape, but so are the spaces between them.

Do space things out unevenly, making them different sizes and shapes. Now some of the trees are clustered together. Some are smaller and others are larger. The trees are different sizes and shapes, and so are the spaces between them. The composition is a lot more interesting.

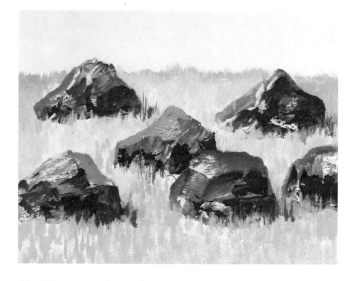

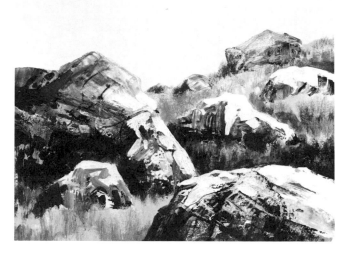

Don't scatter things all over the landscape so the eye keeps jumping around. Furthermore, these rocks are dull because they're all roughly the same size and shape.

Do group your most important pictorial elements so the eye knows where to go—in this case, the eye goes to the lighted face of the rock at the center. This composition is also more interesting because the sizes of the rocks have been altered: some are bigger and some are smaller. The spaces between the rocks are more varied too.

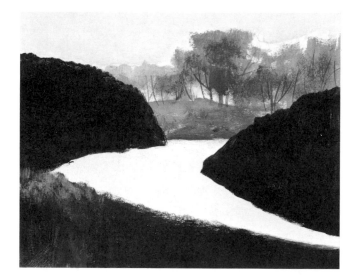

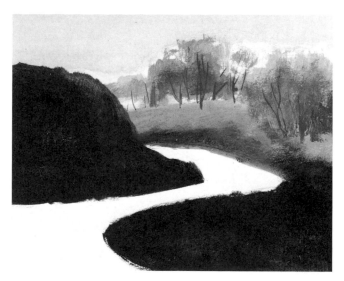

Don't lead the eye out of the picture. Notice how the eye starts out at the center of the curving stream and is then pulled out of the composition toward the lower right corner.

Do lead the eye into the picture. Now the eye enters the picture at the lower left, winds around to the right, then swings back toward the center. This "rule" applies not only to a stream, but to a path, a wall, or a row of trees.

Mountains in Side Light. Observe the direction of the light whenever you start to paint any landscape subject. The light can completely transform the shapes of the landscape. The sunlight is coming from the right side of this mountain, throwing the right slopes into bright sunlight and plunging the left slopes into deep shadow. This kind of lighting emphasizes the three-dimensional quality of the forms.

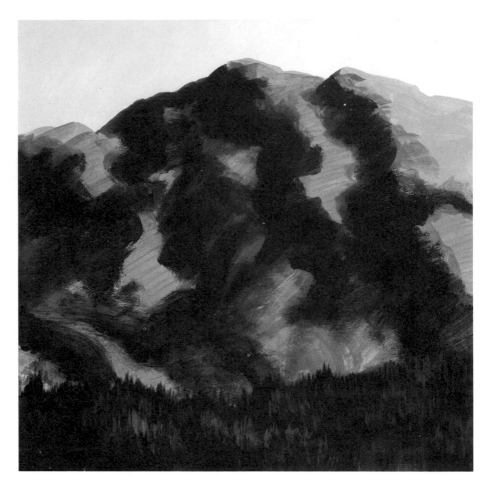

Mountains in Back Light. Early in the morning or late in the day, the sun starts to sink behind the horizon. At that time, the same mountain becomes a dark silhouette against the glowing sky. Now you can no longer see distinct planes of light and shadow, but one dark shape. Many landscape painters love to work in the early hours of the morning or just before sunset because they like to capture these strong silhouettes.

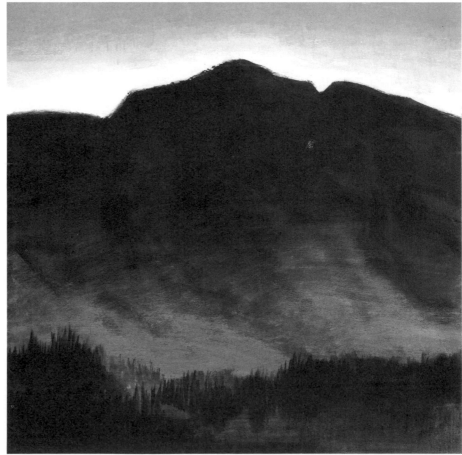

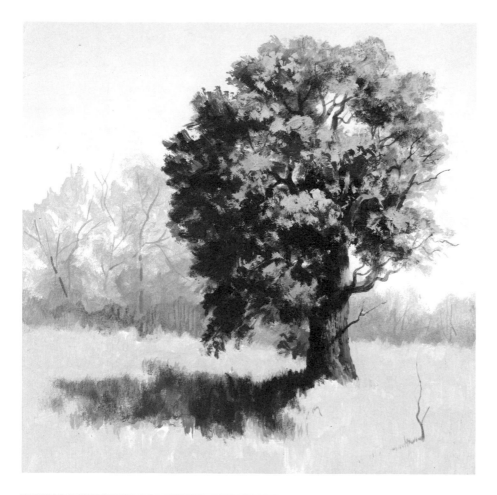

Tree in 3/4 Light. The light falls on this tree from the upper right. Thus, each cluster of leaves has its own distinct pattern of light and shadow. The top and right side of each cluster is in the light, while the bottom and left side is in shadow. The trunk follows the same pattern: light on the right and shadow on the left. On the ground, the tree casts its shadow to the left.

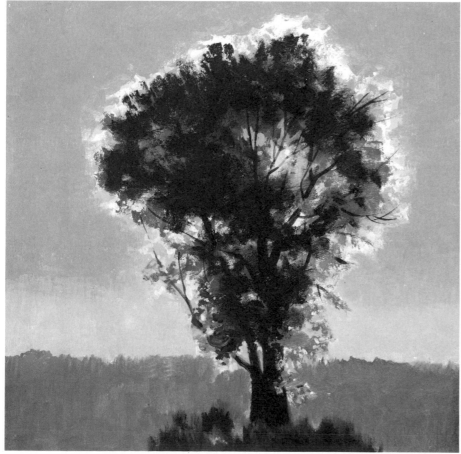

Tree in Rim Light. When the sun is directly behind a shape—such as this tree—the front is in deep shadow and the edges often glow like a halo. This effect is called rim lighting. It's one of the most dramatic effects in landscape painting.

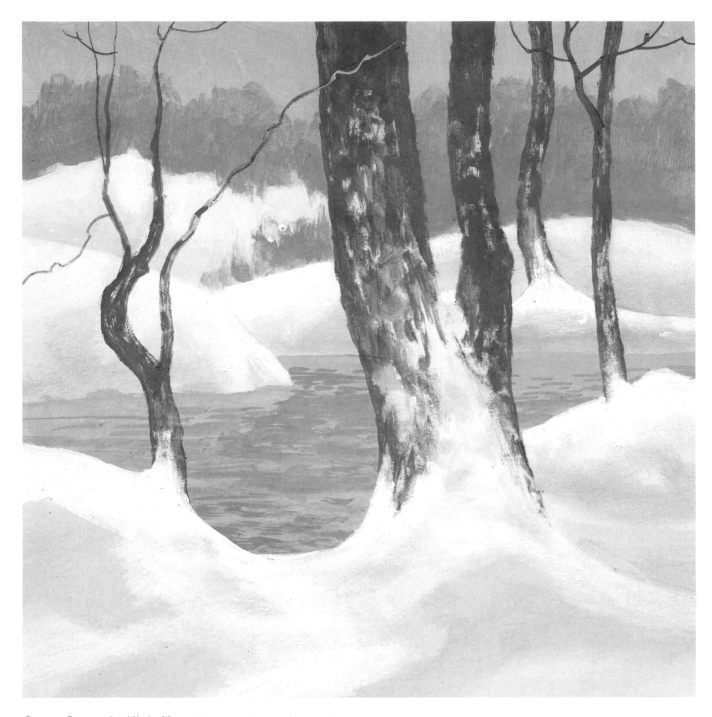

Snow Scene in High Key. The term *key* refers to the overall lightness or darkness of the subject. A high-key painting is generally light—even the darks are fairly pale. A misty or hazy landscape is often a high-key subject. In this high-key snow scene—painted on a misty, overcast day— the shadows on the snow are only a little darker than the sunlit patches of snow. The dark trunks *are* darker than the shadows, but they're still quite pale. Before you start to paint *any* landscape subject, try to determine whether it's high key, low key, or somewhere between.

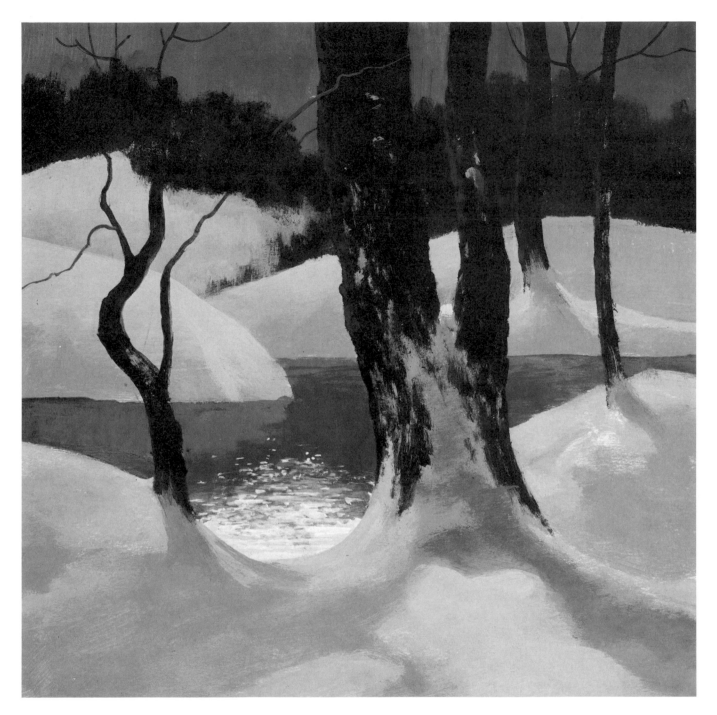

Snow Scene in Low Key. Here's exactly the same snow scene painted in a much lower key, which means that the landscape is generally dark. Low-key landscapes are common in the early morning, before the sun rises above the horizon; in the late afternoon, when the sun has dropped below the horizon, but before night sets in; and at night, of course. In this moonlit landscape, even the lighted patches on the snow are quite dark—darker, in fact, than the shadows on the snow in the high-key picture. The shadows on the snow are as dark as the treetrunks on the facing page. Here, the trees are almost black against the murky sky. The only bright light is the reflection of the moonlight in the water. Remember two guidelines. In a high-key landscape, even the darks are pale. Conversely, in a low-key landscape, even the lights are fairly dark.

Dark to Light. A good way to plan a landscape is the so-called three-value system. Before you begin to paint, you identify the values—the relative lightness or darkness—of different parts of the picture. It helps to divide the picture into darks, middletones, and lights, which generally correspond to the foreground, middleground, and distance. In this case, the darkest tones are in the foreground rocks; the middletones are in the sea just beyond; and the light tones are on the distant shore. The sky often forms a fourth tone, as you see here. Naturally, there are further tonal variations within each of these areas, such as the lights and shadows on the rocks or the light and dark waves in the water. Note that the lighted areas on the rocks are *darker* than the shadows on the distant shore. This lesson is worth remembering when you mix your colors. A famous painter used to teach his students the rule: "The shadows in the light are paler than the lights in the shadows!"

Light to Dark. When the light conditions change on this coastal landscape, so does the progression of values. Now the subject moves from light to dark. The foreground rocks represent the lightest area; the sea is the middletone once again; and the distant shore is the darkest shape. The sky is a fourth value, as pale as the tops of the rocks. The shadows of the rocks grow paler, while the lights on the distant shore grow darker. Before they start to paint a landscape, many professionals make a small three-value sketch with three pieces of chalk: one very pale gray, one darker gray, and one black. This value sketch becomes their guide when they mix their colors. Try it.

DRAWING ROCKS

Step 1. Many of your landscape paintings will certainly be done indoors, based on sketches you've made on location. Here are some guidelines for drawing rocks. Start out with a few pencil lines that visualize the forms of the rocks in the simplest possible terms. These rocks begin with straight lines that reduce the rocks to geometric shapes.

Step 2. Now the pencil goes back inside those geometric forms and traces the actual contours of the rocks. When the *outer* edges of the rocks are accurately drawn, then the pencil draws the *inner* lines that divide the planes of light and shadow. Each rock is carefully divided into light and shadow zones.

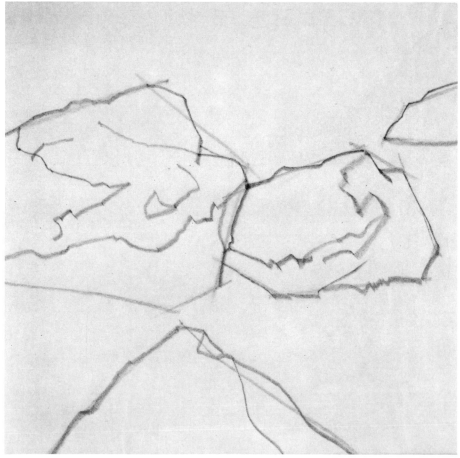

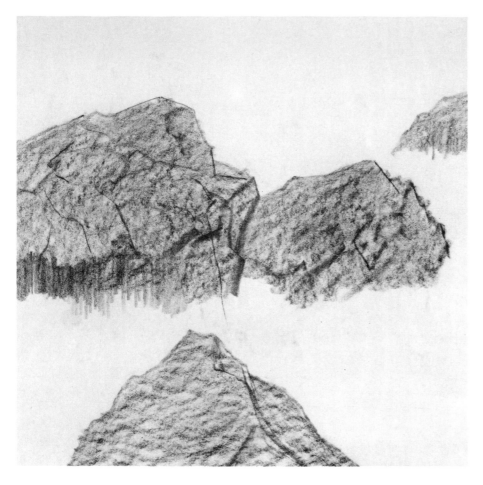

Step 3. The side of the pencil scrubs in the overall tone of the rocks with broad strokes, almost like a brush. The pencil presses harder to begin the dark underside of the big rock to the left. An interesting trick is tried here. The drawing paper is laid over some heavily textured surface—a piece of weathered wood or a book bound in rough cloth—so the pencil strokes become rougher and more irregular. The point of the pencil begins to draw some cracks in the rocks.

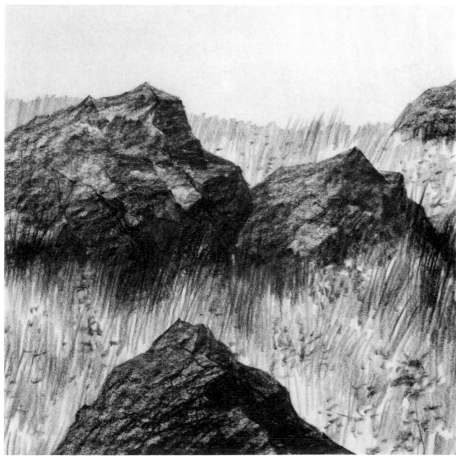

Step 4. Pressing harder still, the side of the pencil darkens the shadow planes of the rocks. The lighter tones of Step 3 are left to represent the sunlit tops. The surrounding meadow is completed with rapid up-and-down strokes of the pencil point to suggest grass and weeds. These strokes are carried upward into the dark shadows of the rocks, which seem to merge softly into the grass. Quick touches of the pencil point suggest wildflowers.

Step 1. Working indoors, you'll certainly want to have sketches of various cloud effects. When you're drawing clouds, you've got to work quickly before the wind changes these fast-moving shapes. This cloud study begins with free, rapid lines that define the shapes of the clouds and the patches of darker sky between them.

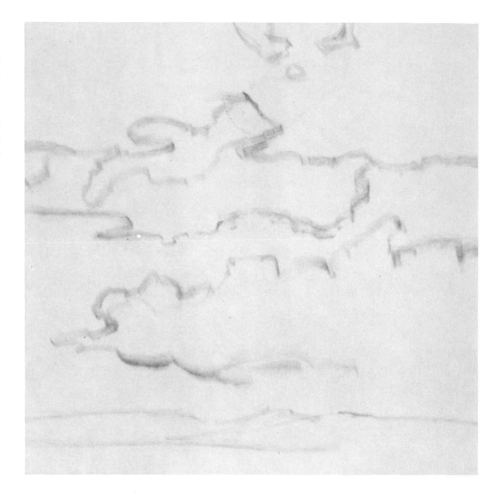

Step 2. The side of the pencil is used like a brush to block in broad tones of sky between the clouds. Get to know the different pencils in your art supply store. They're usually marked H for hard and B for soft. The hard pencils make lines that are gray and slender. Soft pencils make lines that are darker and broader. Artists generally prefer the soft ones. They're numbered to indicate the degree of softness, which means blackness. A 4B, which is used for this sky study, is softer and blacker than a 2B.

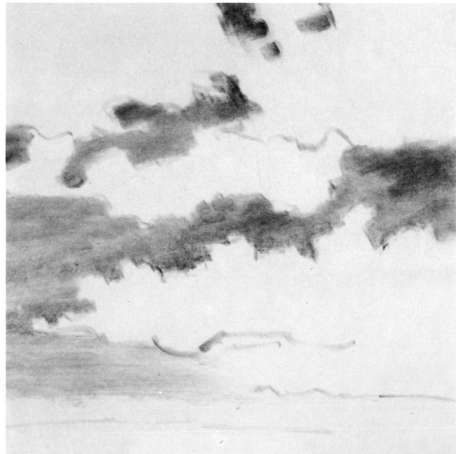

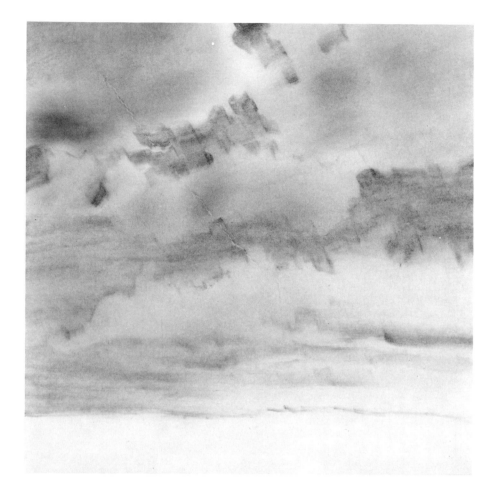

Step 3. The marks of a soft pencil are easy to smudge with the fingertip. Here, a finger smudges, blends, and lightens the sky tone. Now the fingertip is covered with the black graphite of the pencil and is used to darken the undersides of the clouds. You can use a fingertip just like a brush!

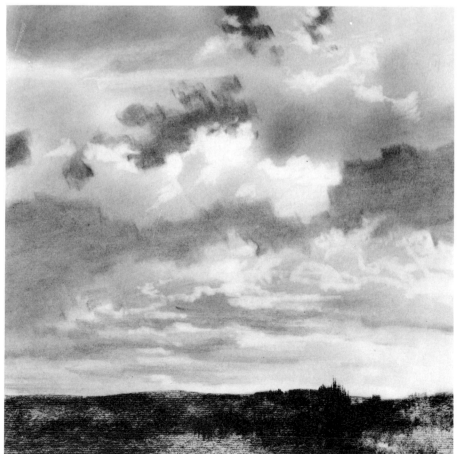

Step 4. The side of the pencil darkens the patches of sky and adds more darks to the undersides of the clouds. A kneaded rubber eraser (called putty rubber in Britain) is squeezed to a sharp point, like clay, and used to clean away some of these gray tones to create luminous lights among the clouds. The tip of the eraser actually "draws" white lines among the dark smudges of the lower sky. The landscape below is completed with dark pencil strokes untouched by the fingertip. These crisp, dark strokes contrast nicely with the soft, smudged strokes of the sky.

Step 1. When you start to draw a tree, the most important thing is to focus your attention on the overall shape of the tree, not on the individual clusters of leaves or the individual branches. Try to fit the shape of the tree into some simple geometric figure. This tree begins with six straight lines to form a six-sided geometric shape. Then the trunk of the tree is carried from the ground upward into the center of the geometric figure. The drawing is done with a 2B pencil on smooth, white drawing paper.

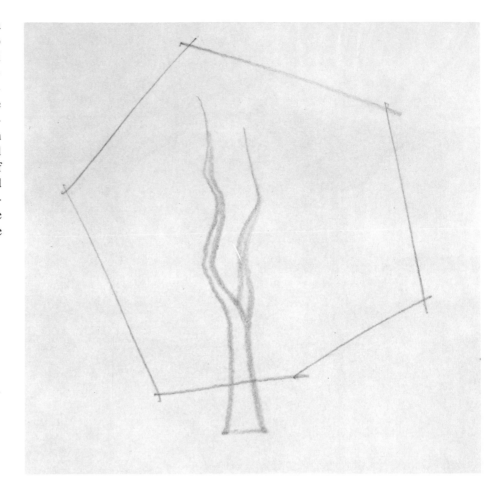

Step 2. A few branches are added to the treetrunk with the tip of the pencil. Then a diagonal line is drawn across the midpoint of the geometric shape to indicate that the top half is just one big leafy mass. Some curving lines are drawn below to define the more irregular clusters of leaves that will appear in the lower half of the tree.

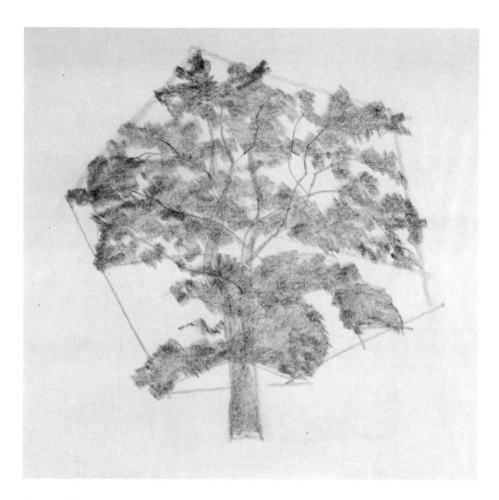

Step 3. The side of the pencil begins to scribble in the masses of leaves with an even, gray tone. The pencil is simply moved back-and-forth with a scribbling motion, gradually filling the shapes with tone. The upper half of the tree is almost completely covered with leaves, leaving just one gap of sky. This tone fills the curving lower lines that appeared in Step 2. Now the entire tree is covered with a middletone.

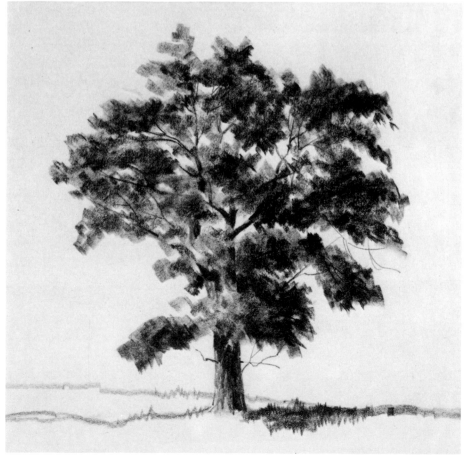

Step 4. The tree is completed by scribbling in the shadows, pressing harder on the pencil to make darker strokes. The dark strokes are short and decisive. The side of the lead also darkens the shadow sides of the trunk and branches. The point of the pencil strengthens the lines of the smaller branches and twigs. Scribbly, horizontal lines suggest the landscape beneath the tree. And some dark, up-and-down scribbles indicate a shadow to the right of the tree. Remember the drawing sequence: overall shape; secondary shapes within the overall shape; middletones; darks and details.

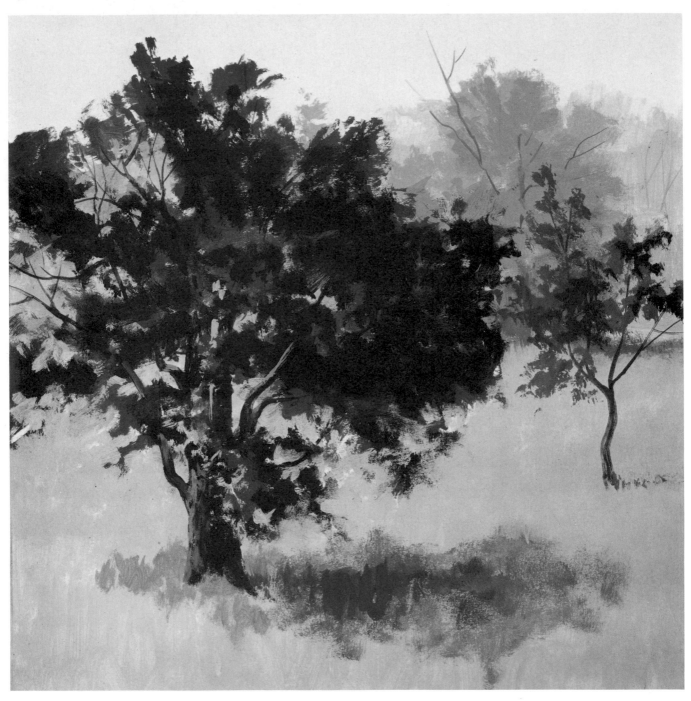

Foreground, Middleground, Distance. To give your landscapes a convincing feeling of deep space, observe the "rules" of aerial perspective. According to these "rules," the nearest objects look darkest, contain the strongest light and dark contrasts, and reveal the most precise detail. You can see this in the tree that occupies the immediate foreground. Objects in the middle distance are not quite as dark, show less contrast between light and shadow, and reveal less detail—like the smaller tree just beyond the big tree. Distant objects are paler, show the least contrast between light and shadow, and reveal very little detail—like the pale, highly simplified shape of the tree at the horizon. To see how aerial perspective works in a variety of subjects, look back at the landscape demonstrations in the color section. It should be easy to identify foreground, middleground, and distance, and see how they conform to the "laws" of aerial perspective. As objects recede into the distance, they not only grow paler, but cooler—which means bluer or grayer.